MOTHERS

HERS

MOTHERS

MOTHERS

A LOVING CELEBRATION

COURAGE
BOOKS

AN IMPRINT OF RUNNING PRESS

PHILADELPHIA • LONDON

9 8 7 6 5 4 3
Digit on the right indicates the number of this printing

Library of Congress Cataloging-in-Publication Number 96-71607

ISBN 0-7624-0050-1

Designed by Corinda Cook
Cover art: Detail from *The Three Ages* (1905), by Gustav Klimt.
Picture research by Susan Oyama
Research by Joan McIntosh
Edited by Tara Ann McFadden

Courage Books, an imprint of
Running Press Book Publishers
125 South Twenty-second Street
Philadelphia, Pennsylvania 19103-4399

CONTENTS

INTRODUCTION

SHE OFFERS US A SMILE OF DELIGHT, a soft cheek to snuggle, and is always ready with a warm embrace. Mother—the very word inspires all who have had the pleasure to feel the comfort in her embrace and experience the joy in her smile.

Mothers are life-givers, caretakers, teachers, and friends. The inseparable bond between mothers and their children begins at the moment of conception; the mother is introduced to a whole new world and knows she has received a blessing unlike any other. A mother answers her child's hungry cry, feels joy at the first smile and first step. She treasures the idea that a piece of her heart will be walking—and running—around in someone else's little body. In the early morning hours, when mother and child are at peace, rocking to and fro, all is right in the world.

Mothers

Together they experience the contentment of quiet time. Mothers explain why the sky is blue and how the snow is made. Their infinite wisdom and experience is awe-inspiring to a young child.

As her child begins to take care of itself, the mother learns to let go; she changes roles and becomes a friend and confidante. You can always hear the pride in her voice as her "baby" accomplishes its dreams. Her love is manifested in hugs and kisses but also in her consistent support of everyday accomplishments. Mothers have a unique ability to understand their children when no one else can. They will always be ready with advice for their grown children— even when it's unsolicited.

Children express their love for their mothers with gifts of flowers, poetry, or artwork for the refrigerator door. Each token is carefully prepared by the child and treasured until the next one arrives. Here is one such token. Inside these pages you'll find expressions of love and admiration from artists and writers who have all benefitted from a mother's love. *Mothers* is a tribute to the women who have shaped lives and left a priceless legacy of ceaseless devotion and unconditional love to all that they have touched.

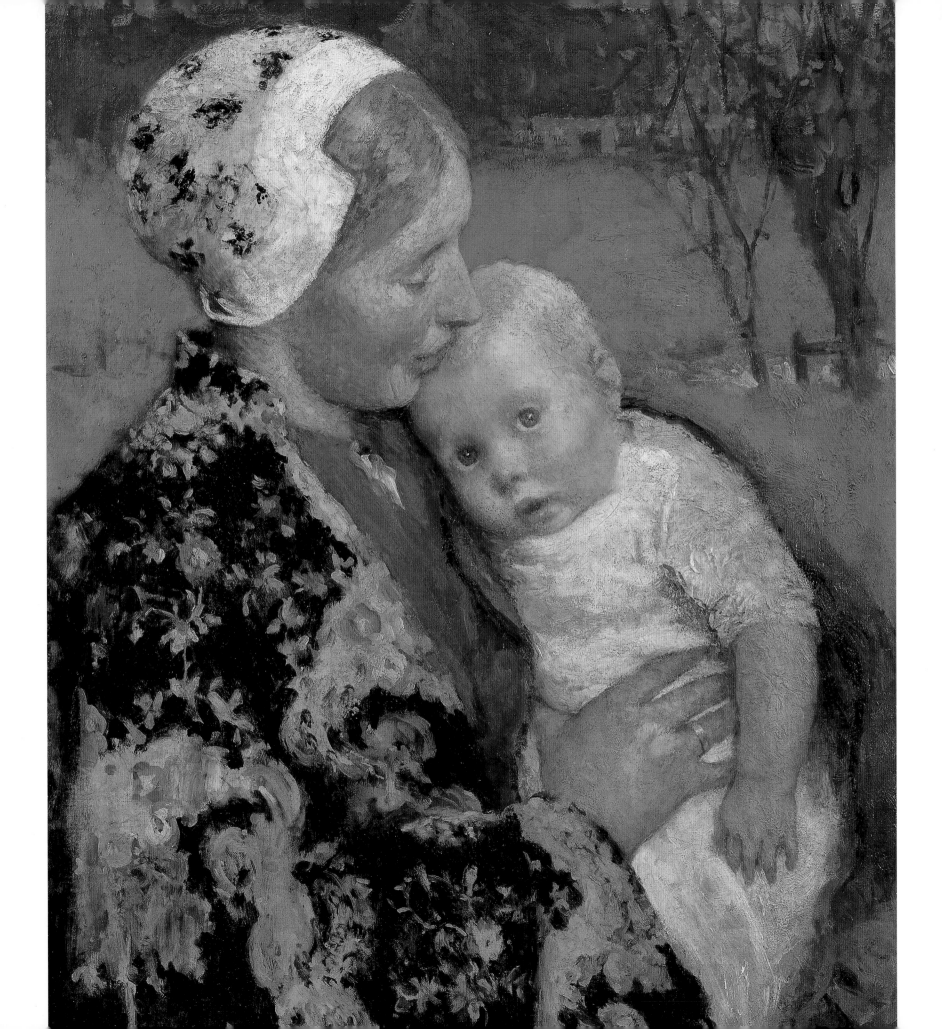

INITIATION

T his was an initiation, through which I experienced a

profound kinship with all women throughout history who had ever gone

through this ordeal and transformation. There was nothing that

distinguished me from any woman who had ever given birth to a baby.

Jean Shinoda Bolen (b. 1936)
American analyst, educator, and writer

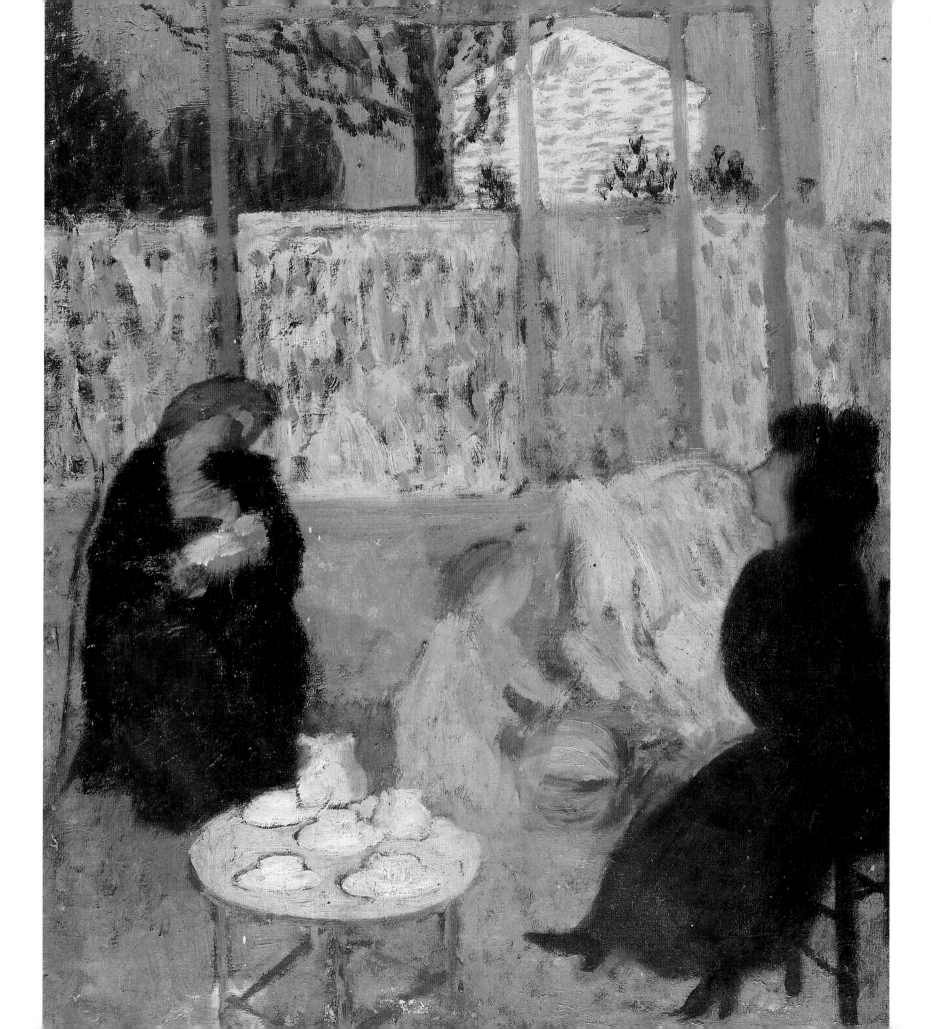

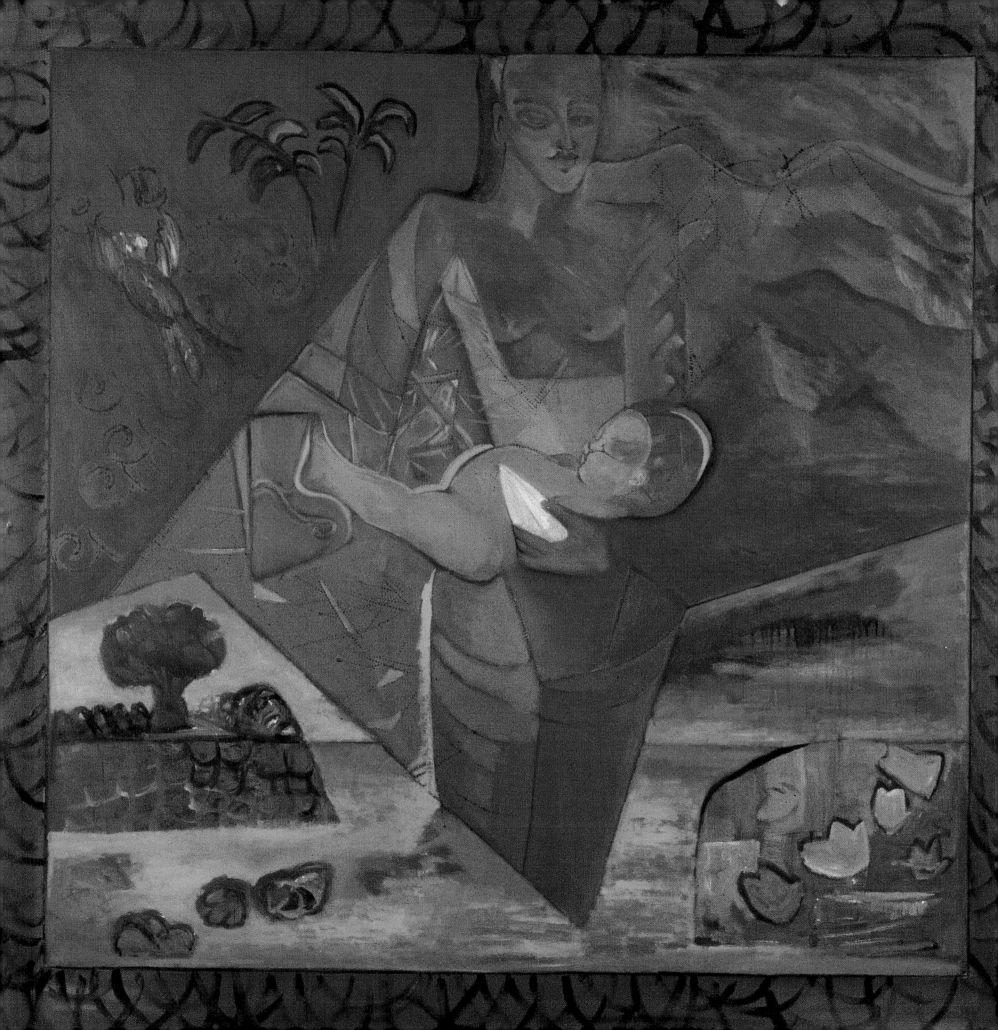

"You are the caretaker of the generations,

you are the birth giver," the sun told the woman.

"You will be the carrier of this universe."

Brule Sioux

Sun Creation Myth

Two new people were born in that moment

Justin was born newly into this world and I was reborn. . . . Gone was the self-centered twenty-three year old student, more still a girl than a woman. I had labored to bring a child into the world, and the fear and pain I suffered had somehow awakened a new compassion in my heart. I could never more return to my pretransition existence, for I had been born into motherhood and must now be initiated into the mysteries of womanhood—the nourishing life.

Joan Borysenko
American psychologist and writer

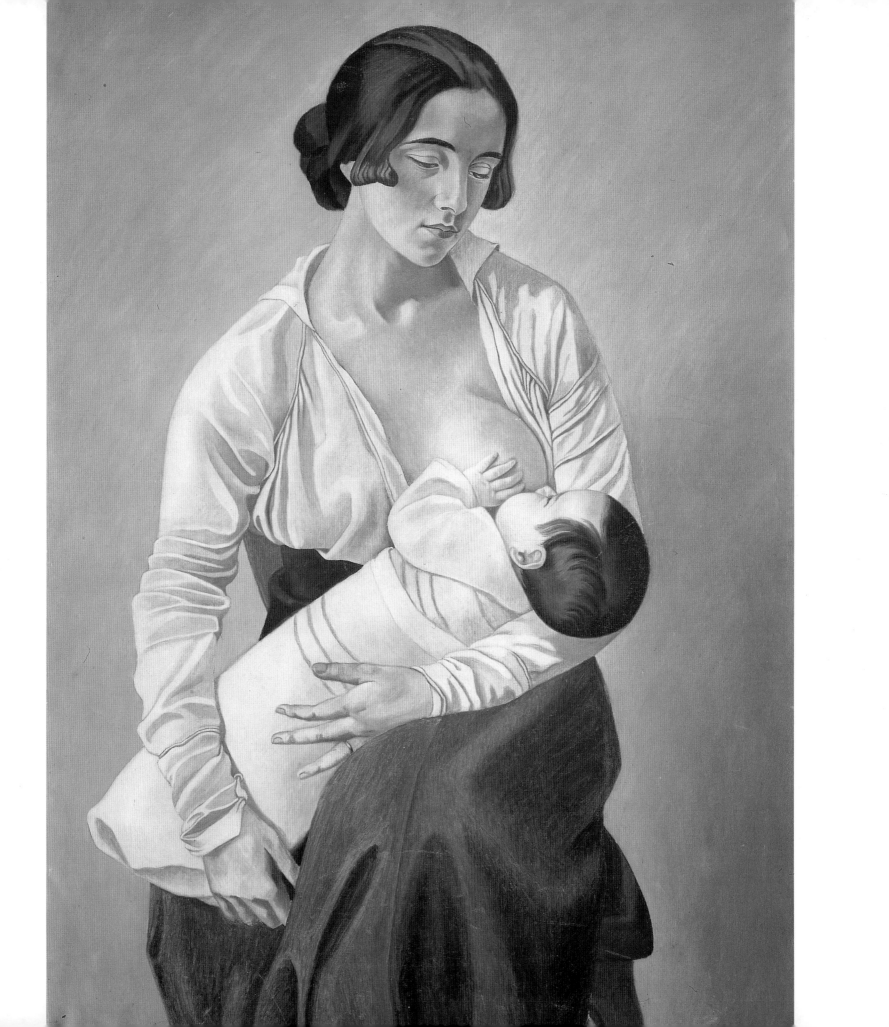

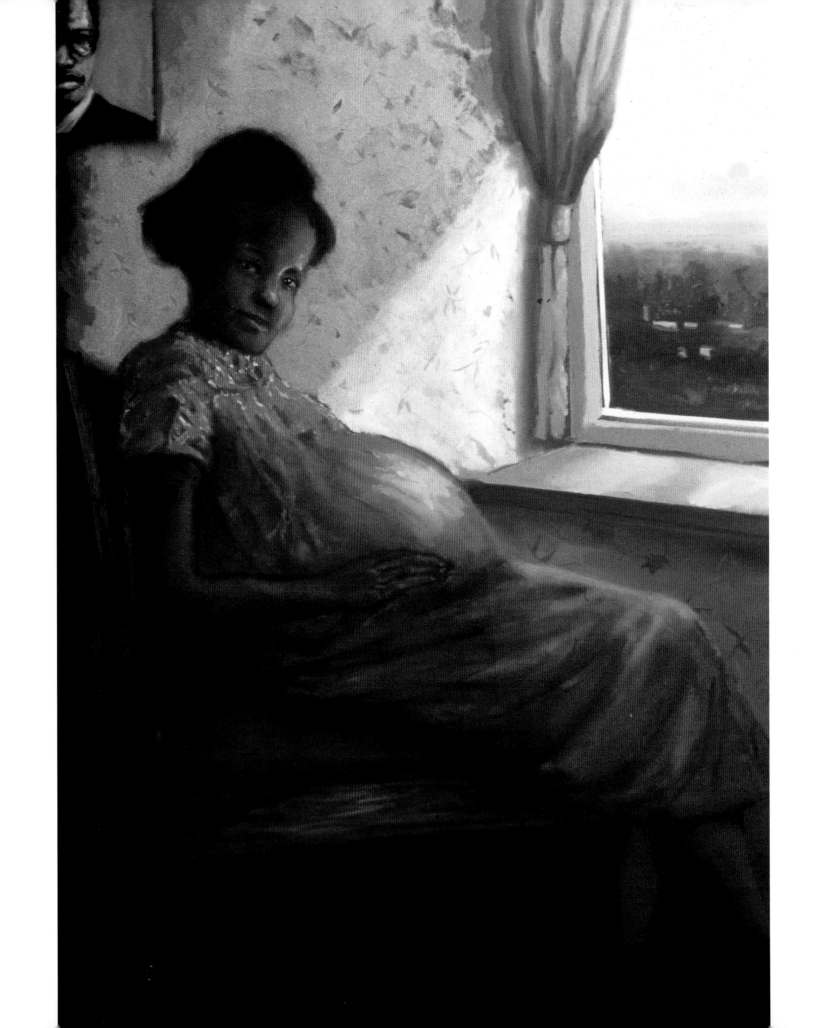

. . . It's the state of being pregnant,

as if you're weaving a house for your child out of your own body,

and it takes all your energy, all your attention.

Hilma Wolitzer
American writer

. . . *everything grows rounder* and wider and weirder,

and I sit in the middle of it all and wonder who in the world you will turn out to be.

Carrie Fisher (b. 1956)

American actress and writer

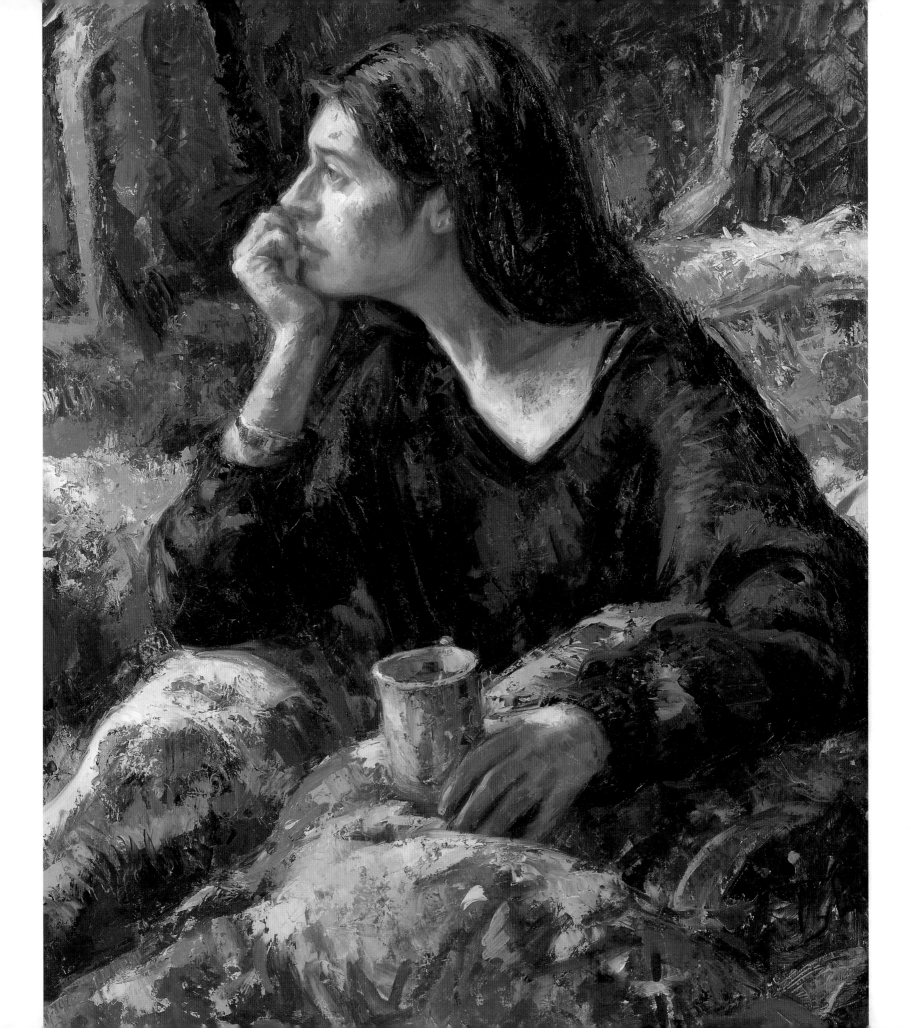

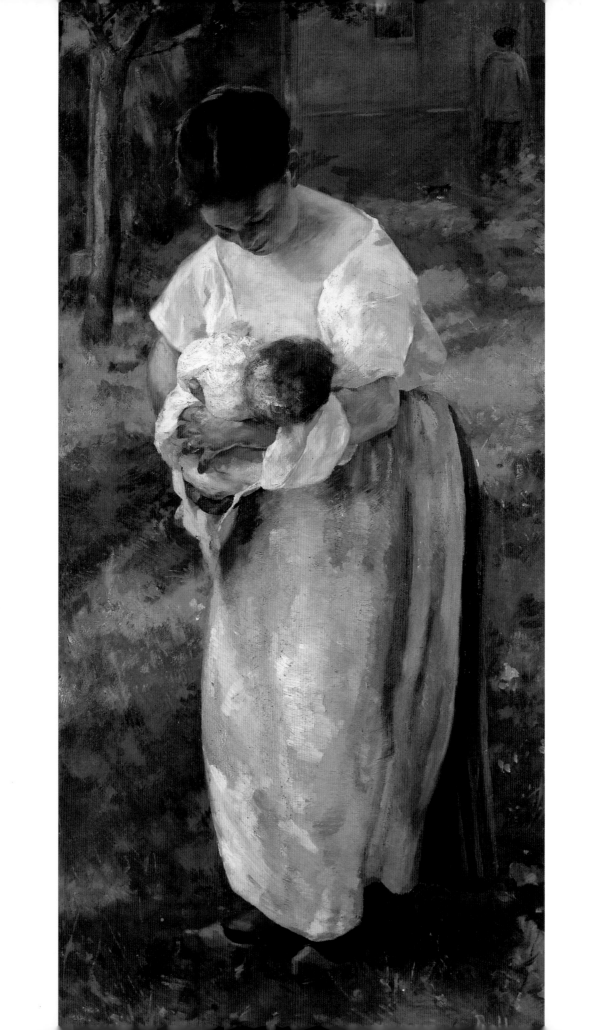

*Y*our mother loves you like the deuce

while you are coming. Wrapped up here

under her heart is perhaps the coziest time

in existence. Then she and you are one,

companions.

Emily Carr (1871–1945)
Canadian artist

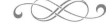

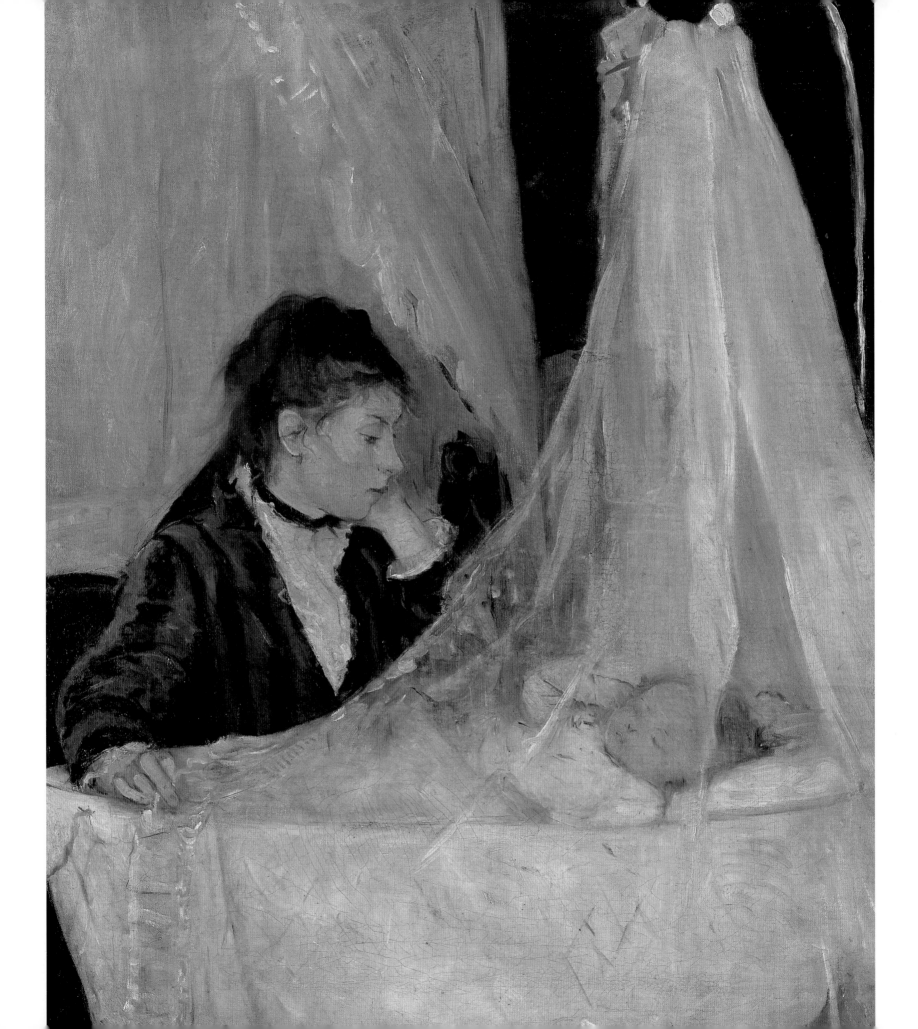

NEW BORNS

I stood in the hospital corridor
the night after she was born. Through a
window I could see all the small, crying
infants, and somewhere among them slept the
one who was mine. I stood there for hours
filled with happiness.

Liv Ullman (b. 1939)
Norwegian-born American actress

TUBS OF FLOWERS WERE ALWAYS MOVED INSIDE THE BIRTH ROOM ON THE PRINCIPLE . . .

THAT THE FIRST THINGS THE EYE OF A NEWBORN SAW SHOULD BE BEAUTIFUL.

Norman Rush (b. 1933)
American writer

She loved him because he needed her;

it was secondary that he happened to be hers, to have

come from her body. He was helpless and he would

move against her as if her body were his own, as if

she were a source of everything he wanted. She knew

that her life would from now on be dictated by that

tiny creature, that his needs would be the most

important thing in her life, that forever and forever

she would be trying to fill that convulsive grasp. . . .

MARILYN FRENCH (B. 1929)

AMERICAN WRITER

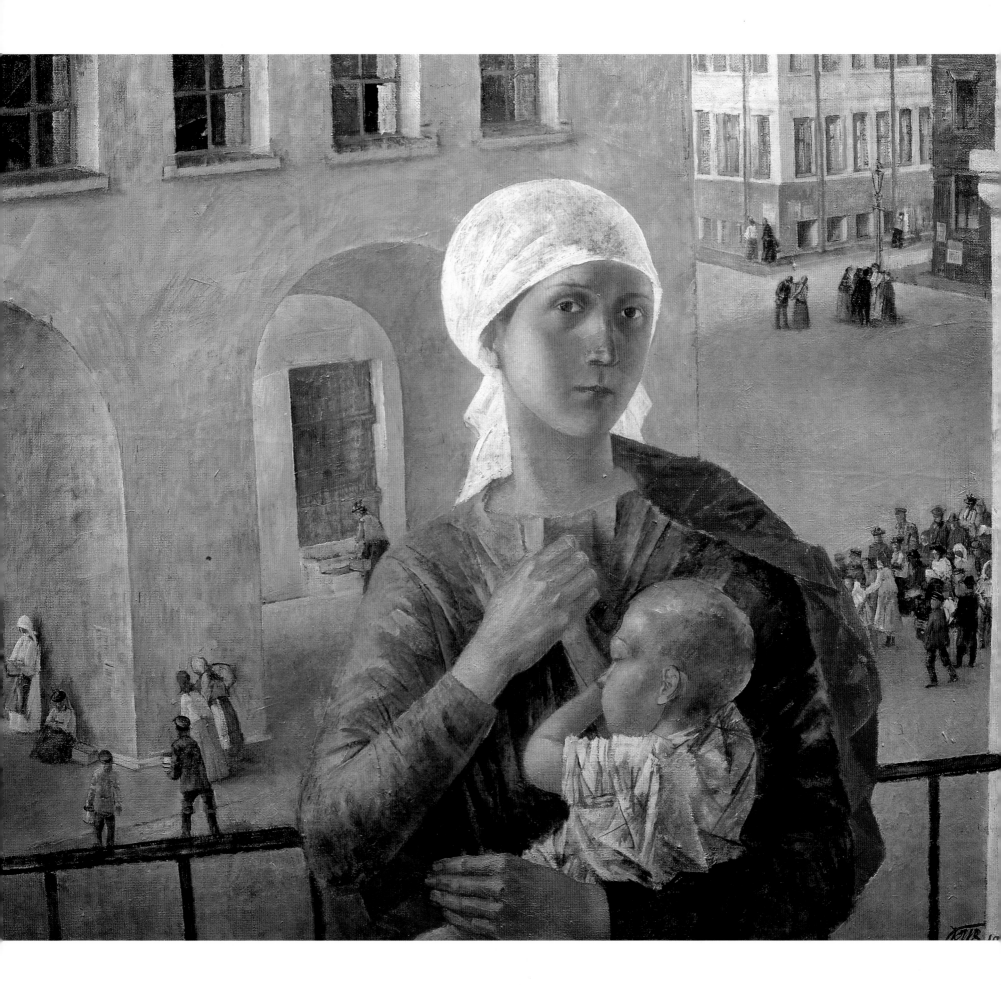

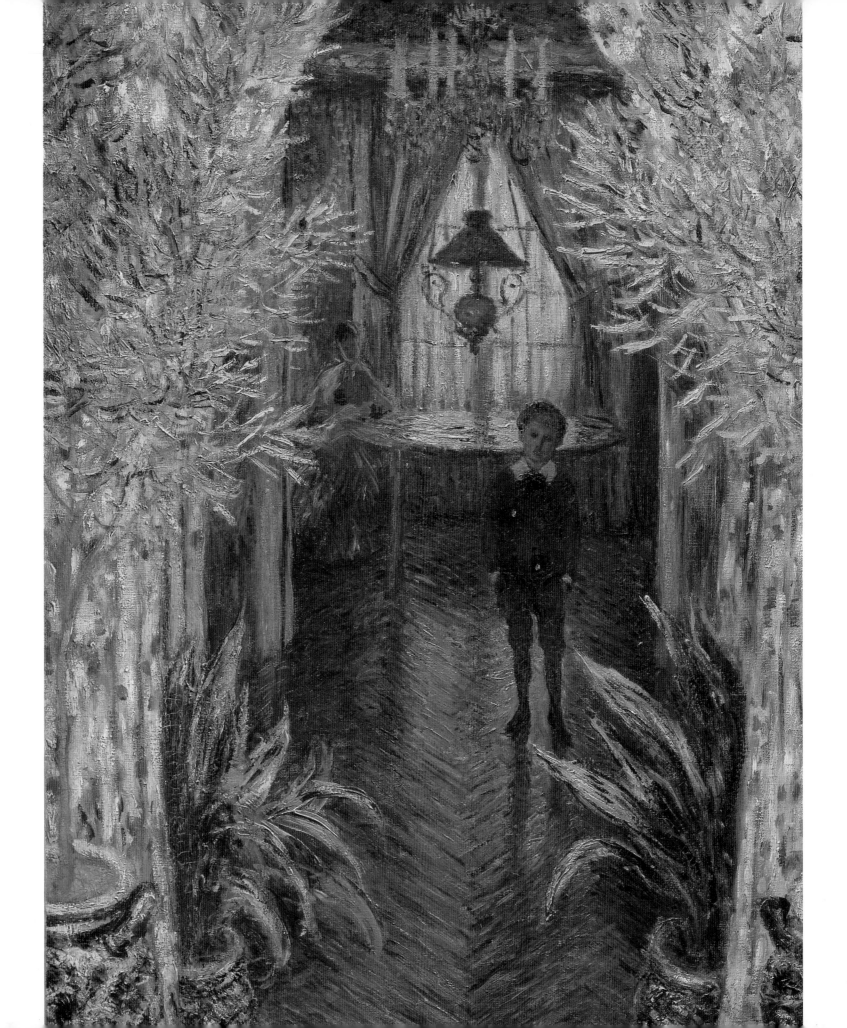

The character and history of each child

may be a new and poetic experience to the parent. . . .

Margaret Fuller (1871–1954)

American writer and poet

THERE AREN'T WORDS YET INVENTED

TO DEFINE THE EMOTIONS A MOTHER FEELS

AS SHE CUDDLES HER NEWBORN CHILD.

Janet Leigh (b. 1927)
American actress

. . . there was something so blissful about smelling the top of a baby's head,

like becoming clean and new again yourself, getting a chance to do it over. . . .

Gail Godwin (b. 1937)
American writer

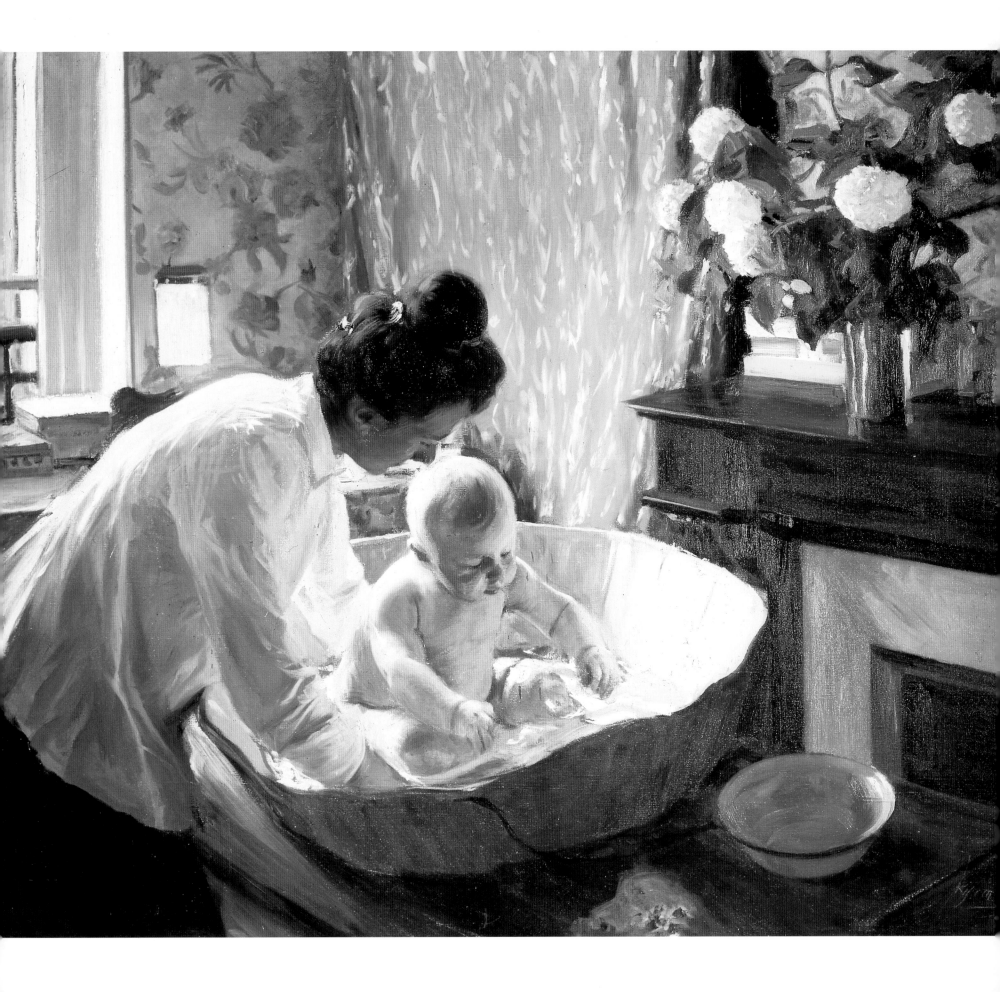

*S*he loved and

accepted her child

the way he was.

In a perfect world,

this would be the

definition of "parent"

in the dictionary.

ANNA QUINDLEN (B. 1952)
AMERICAN WRITER

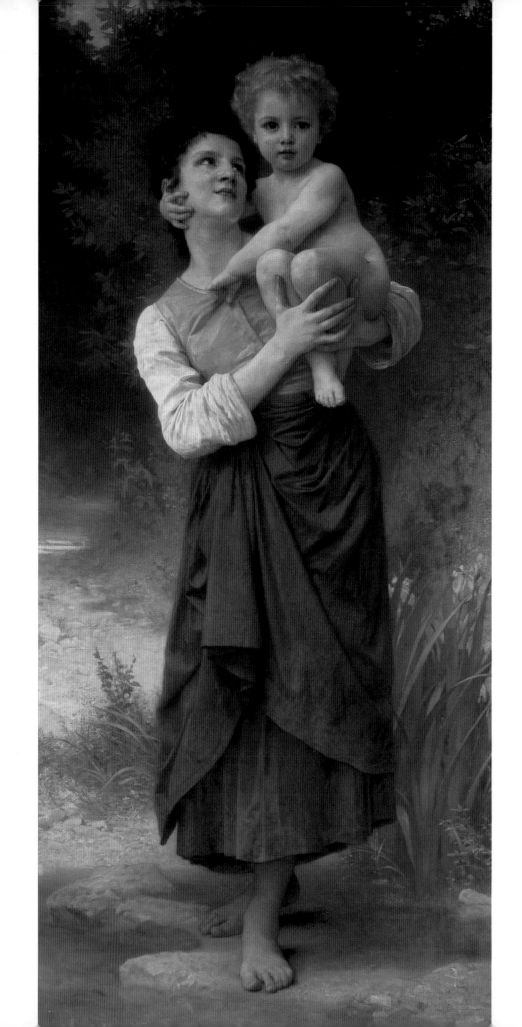

In the sheltered simplicity of the first days

after a baby is born, one sees again

the magical closed circle,

the miraculous sense of two people existing

only for each other,

the tranquil sky reflected on the face

of the mother nursing her child.

Anne Morrow Lindbergh (b. 1906)

American writer and aviator

A mother's love for the child of her body

differs essentially from all other affections,

and burns with so steady and clear a flame

that it appears like the one unchangeable thing

in this earthly mutable life, so that when

she is no longer present it is still a light

to our steps and a consolation.

W. H. Hudson (1841–1922)

Writer

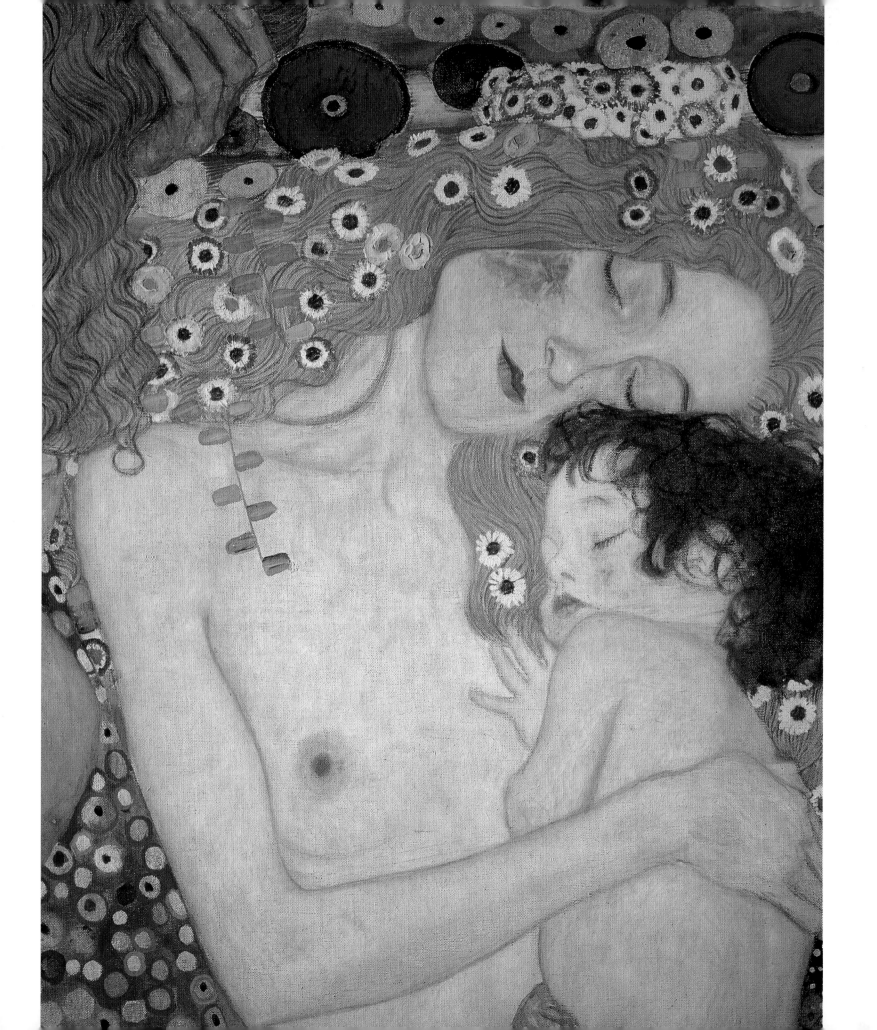

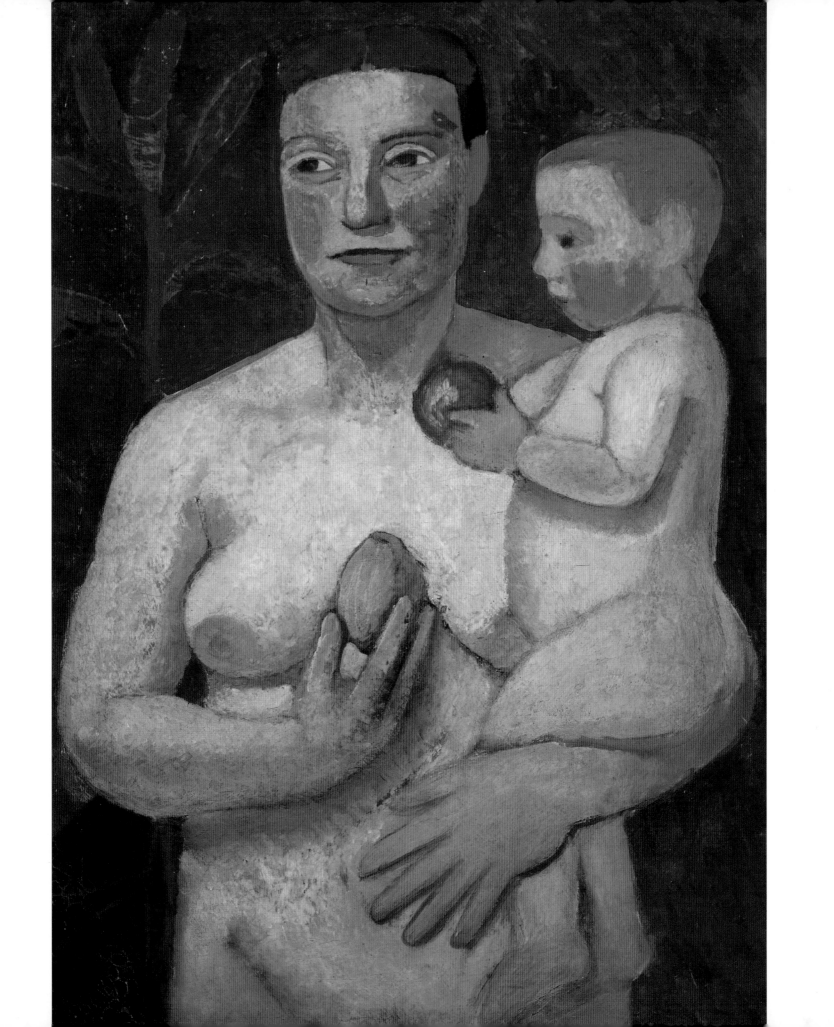

There is an amazed curiosity in every young mother.

It is strangely miraculous to see and to hold

a living being formed within oneself and issued forth from oneself.

⚬

Simone de Beauvoir (1908–1986)

French writer

*M*ilk is the symbol of the first aspect of love, that of care

and affirmation. Honey symbolizes the sweetness of life,

the love for it and the happiness in being alive. Most mothers

are capable of giving "milk," but only a minority of giving

"honey" too. In order to be able to give honey, a mother must

not only be a "good mother," but a happy person. . . .

Erich Fromm (1900–1980)

American psychoanalyst

Mother's arms are made of tenderness, and sweet sleep blesses the child who lies therein.

Victor Hugo (1802–1885)

French writer

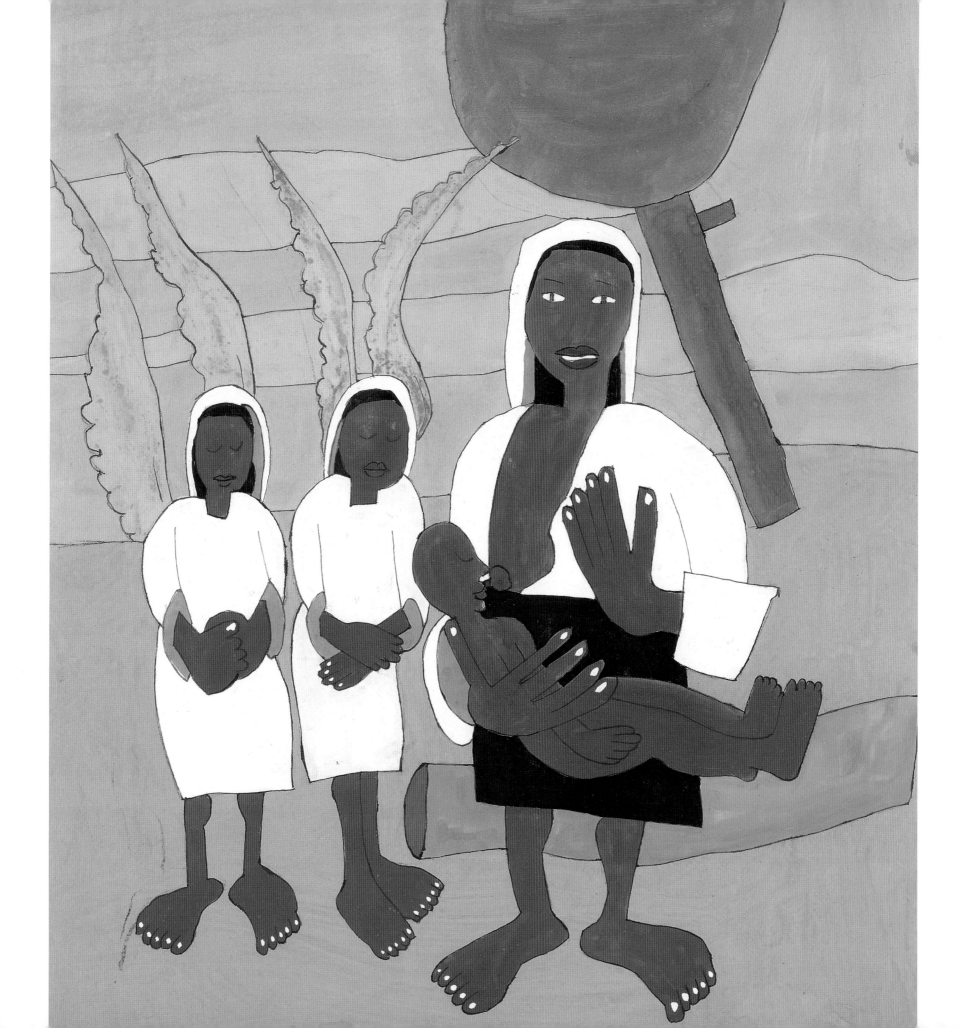

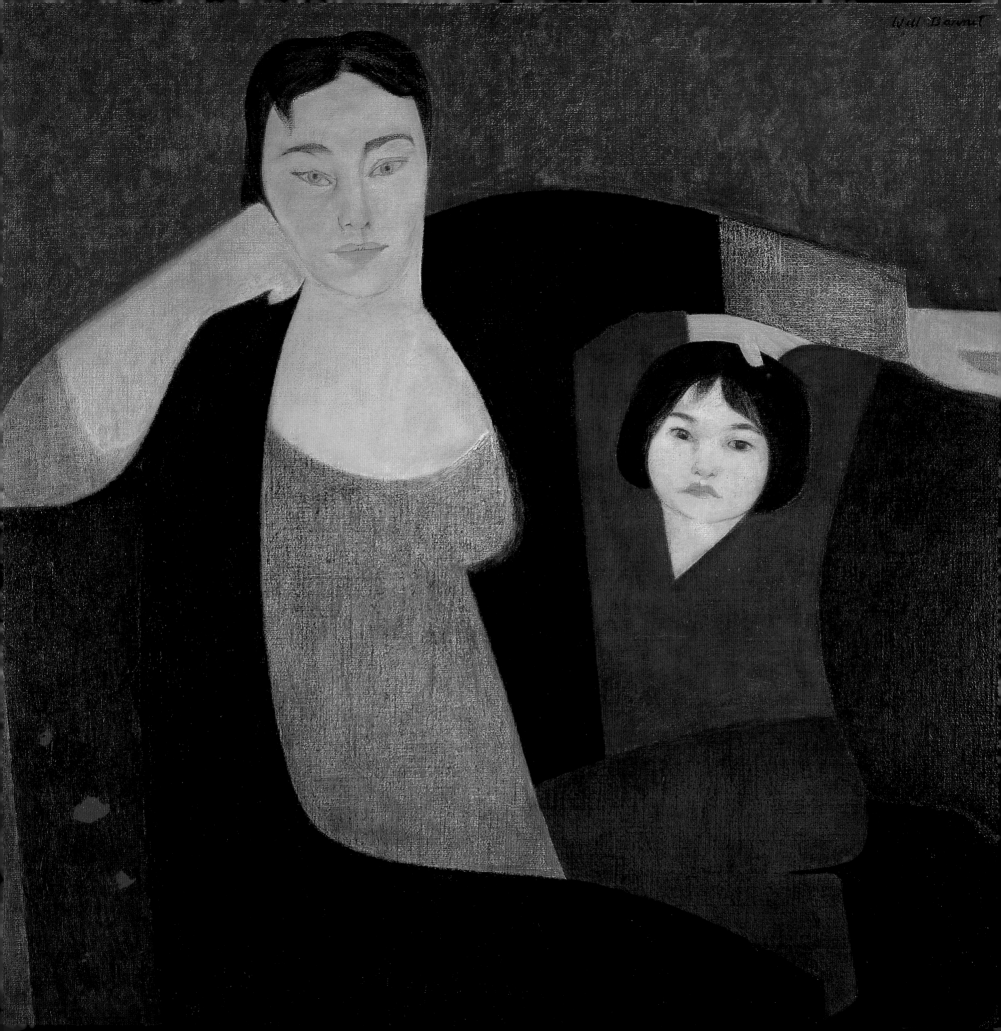

Mother, I love you so.

SAID THE CHILD, I LOVE YOU MORE THAN I KNOW.

SHE LAID HER HEAD ON HER MOTHER'S ARM,

AND THE LOVE BETWEEN THEM KEPT HER WARM.

Stevie Smith (1902–1971)
English poet

I can still remember rocking them to sleep

on my lap in the middle of the night,

to soothe them back to sleep after a stomach ache

or a bad dream, the songs I would make up . . .

Betty Friedan (b. 1921)

American writer

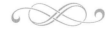

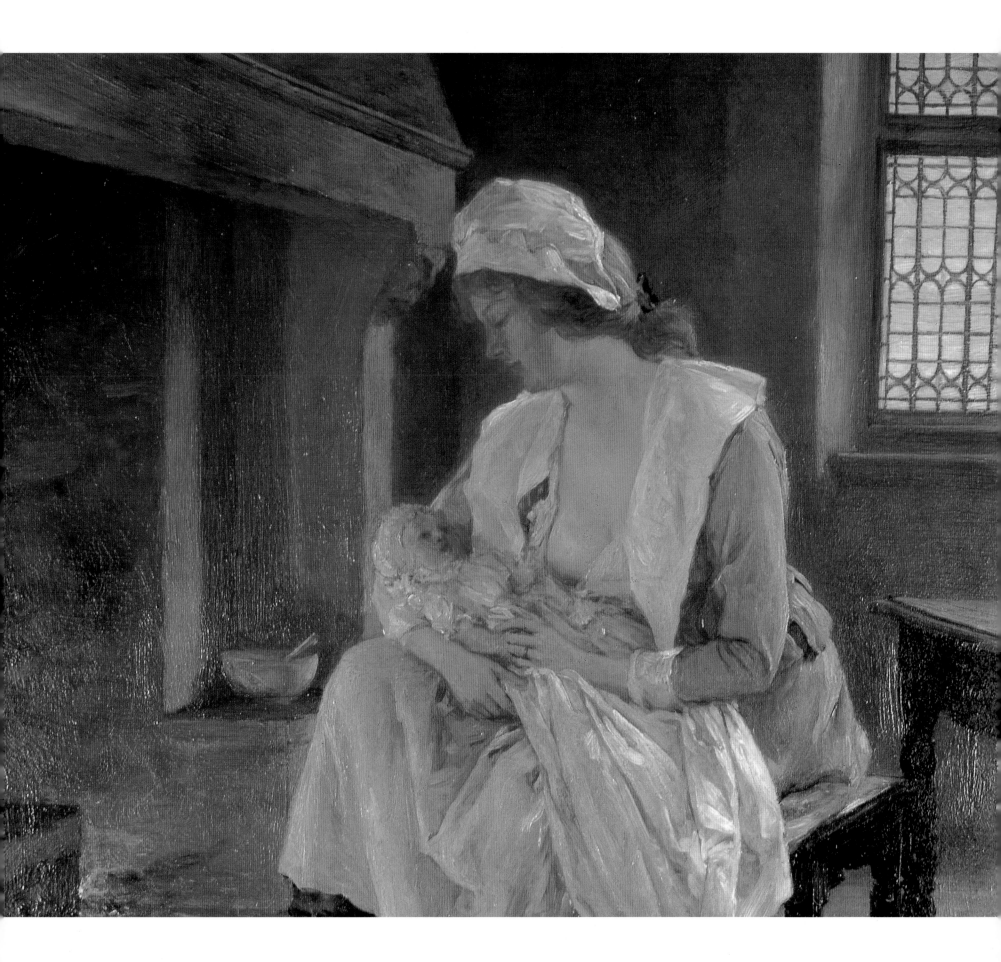

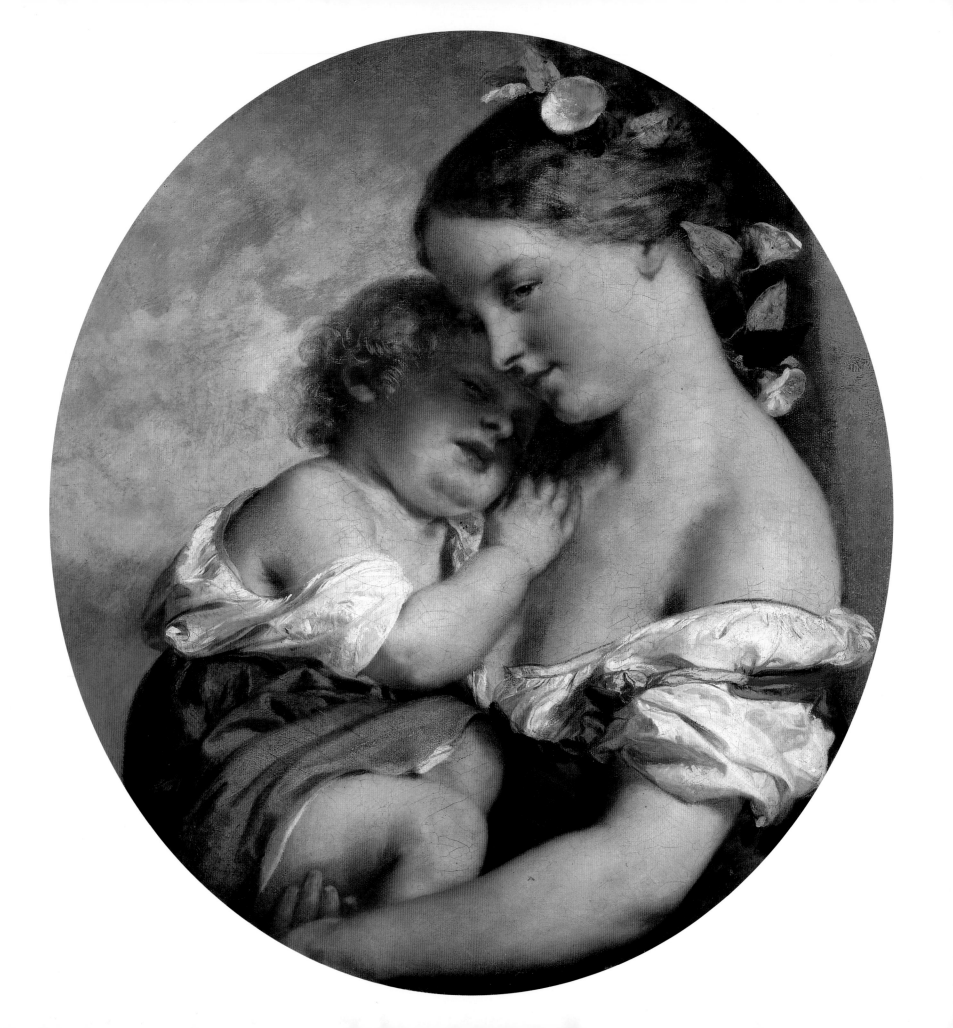

. . . a baby is the best company in the world.

Lee Smith (b. 1944)
American writer

Mothers

Sweet dreams form a shade,

O'er my lovely infant's head.

Sweet dreams of pleasant streams.

By happy silent moony beams.

Sweet dreams with soft down,

Weave thy brows an infant crown.

Sweet sleep Angel mild,

Hover o'er my happy child.

from "A Cradle Song"
William Blake (1757–1827)
English poet and artist

Opening and closing the front door soundlessly,

an art known to mothers of sleeping babies. . . .

Elizabeth Cunningham (b. 1953)
American writer

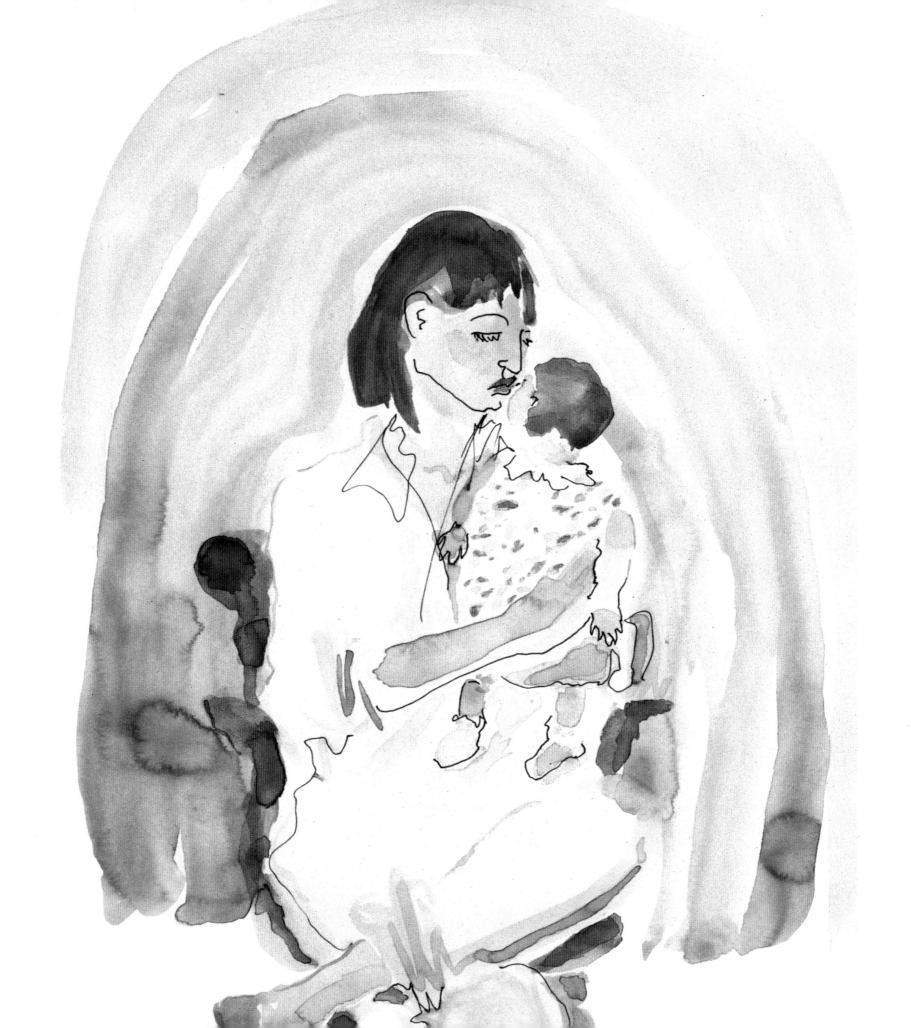

It was tempting to think that if only they could speak,

infants could take us back to their beginning, to the force of their becoming;

they could tell us about patience, about waiting and waiting in the dark.

Jane Hamilton (b. 1957)

American writer

Babies are born wizened with

instinct. They know in their bones what is

right and what to do about it.

Clarissa Pinkola Estés (b. 1943)

American psychoanalyst and writer

49

. . . that's the wonderful thing about babies. 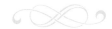 *They love you.*

Marilyn French (b. 1929)

American writer

LET THERE BE SUNSHINE.

LET THERE BE BLUE SKIES.

LET THERE BE MAMA.

LET THERE BE ME.

Old Russian folk song

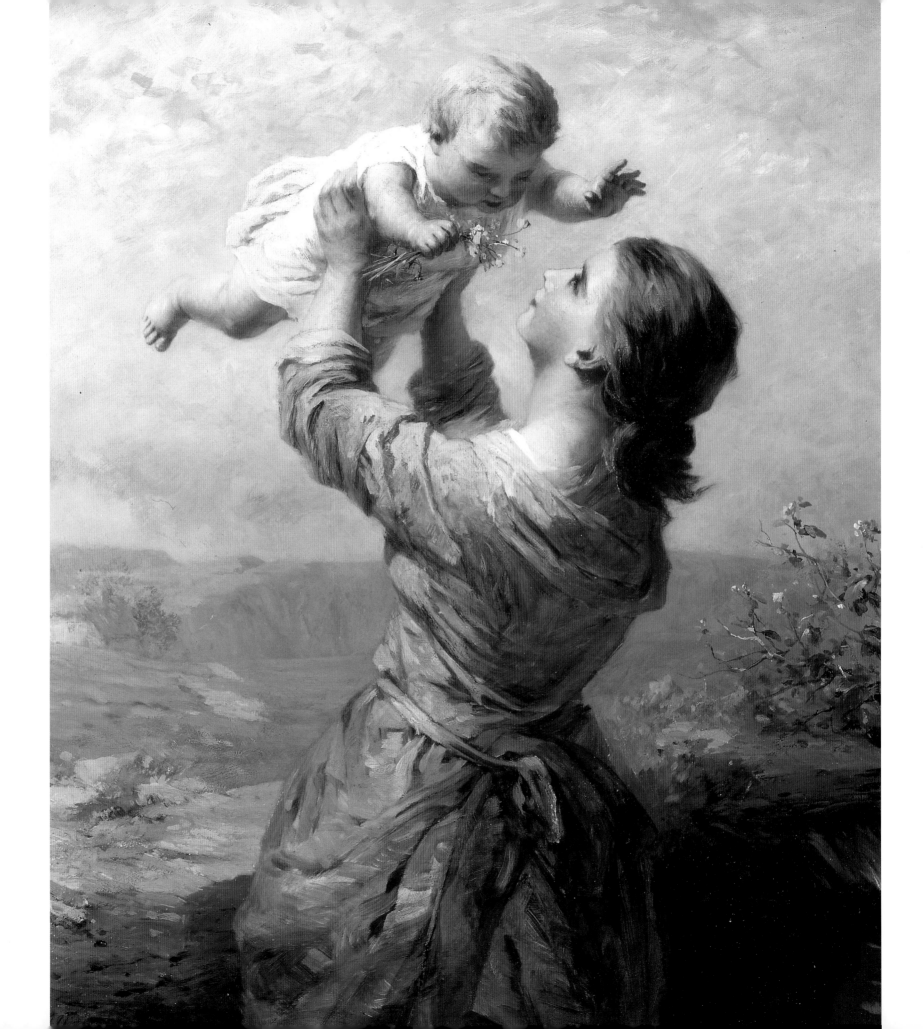

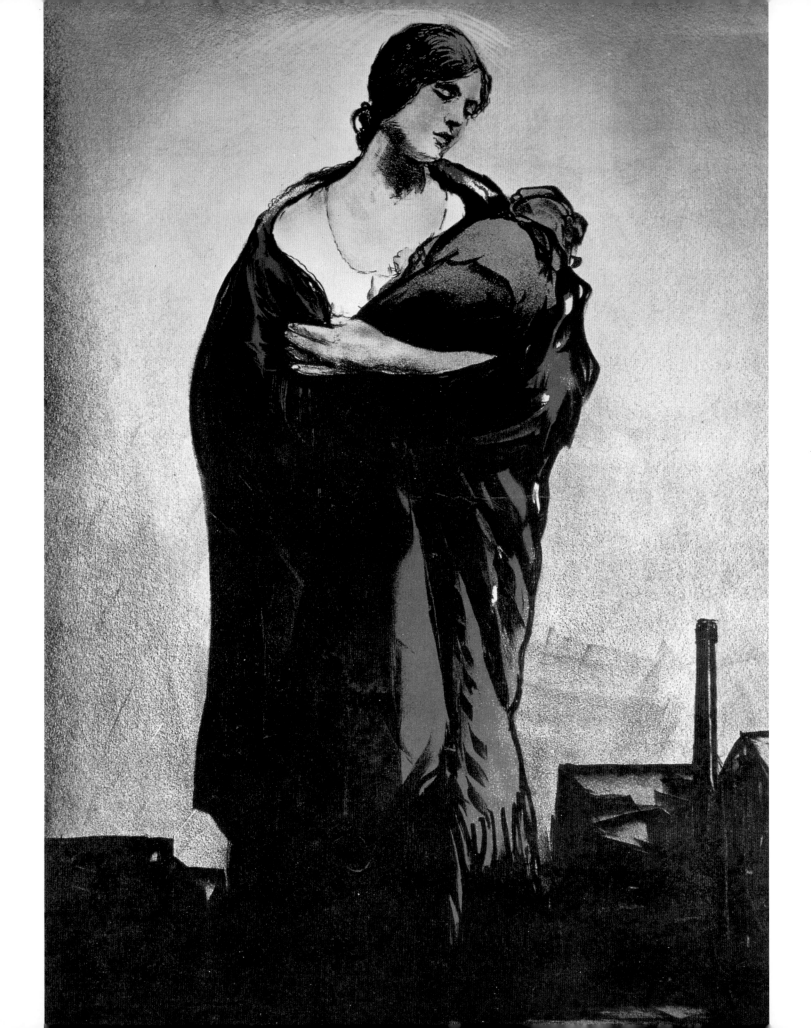

It humbled my ego and stretched my soul.

It awakened me to eternity. It made me know my own humanity,

my own mortality, my own limits.

It gave me whatever crumbs of wisdom I possess today.

Erica Jong (b. 1942)
American writer and poet

Mothers

Golden slumbers kiss your eyes,

Smiles awake you when you rise.

Sleep, pretty wantons, do not cry,

And I will sing a lullaby:

Rock them, rock them, lullaby.

Care is heavy, therefore sleep you;

You are care, and care must keep you.

Sleep, pretty wantons, do not cry,

And I will sing a lullaby:

Rock them, rock them, lullaby.

❦

Thomas Dekker (1572–1632)

English dramatist

. . . a baby . . . puts its arms around your neck and presses its hot cheek against you as it falls asleep, convinced all will be well when it wakes.

Alice Hoffman (b. 1952)

American writer

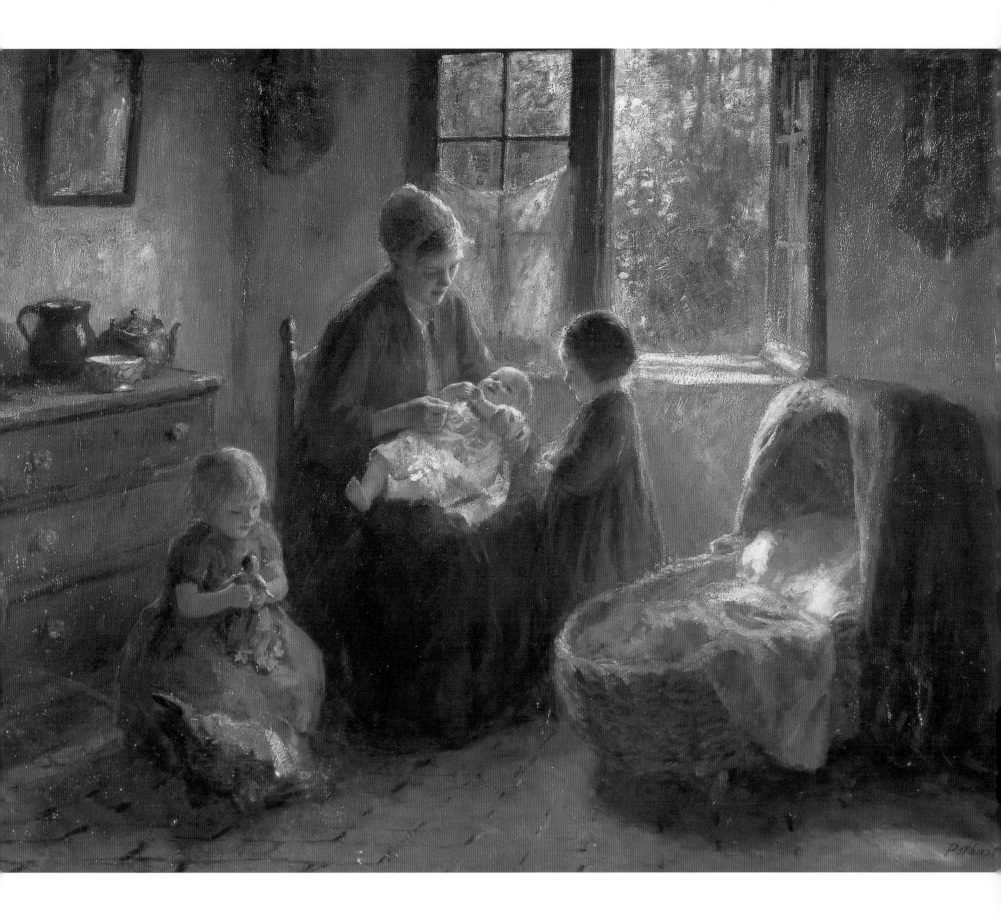

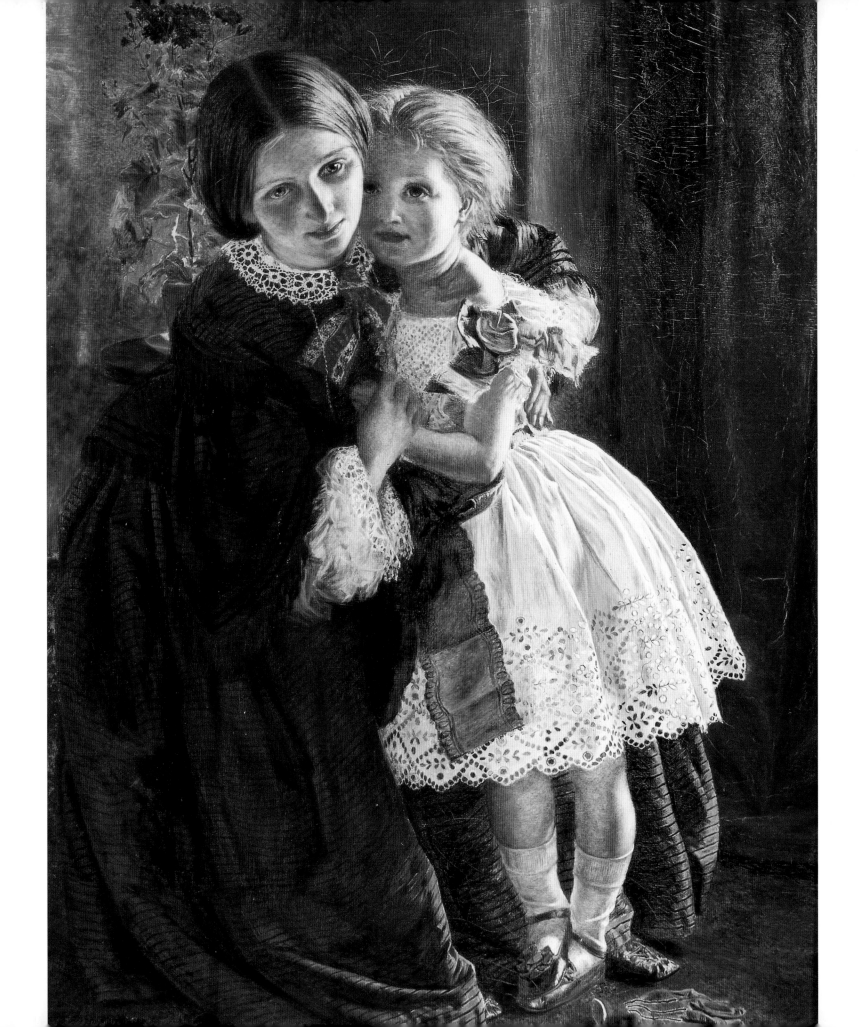

FRIENDS

When you are a mother, you are never really

alone in your thoughts. You are connected

to your child and to all those who touch your lives.

A mother always has to think twice,

once for herself and once for her child.

Sophia Loren (b. 1934)
Italian-born American actress

IT IS NOT UNTIL YOU BECOME A MOTHER THAT YOUR JUDGEMENT

SLOWLY TURNS TO COMPASSION AND UNDERSTANDING.

Erma Bombeck (1927–1996)
American writer

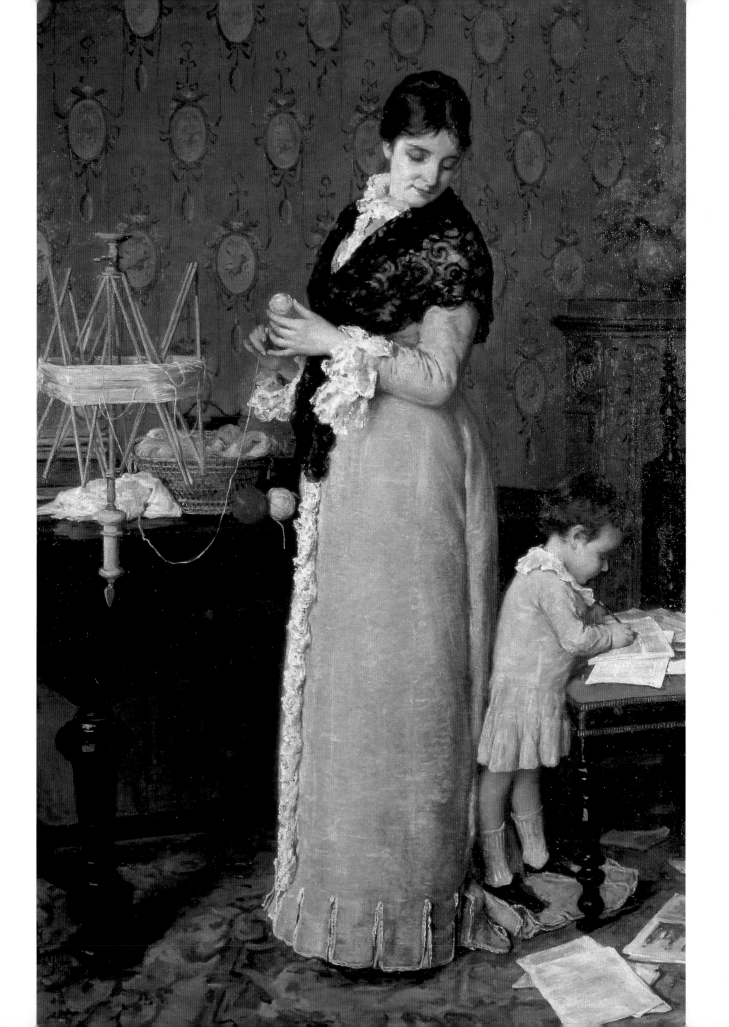

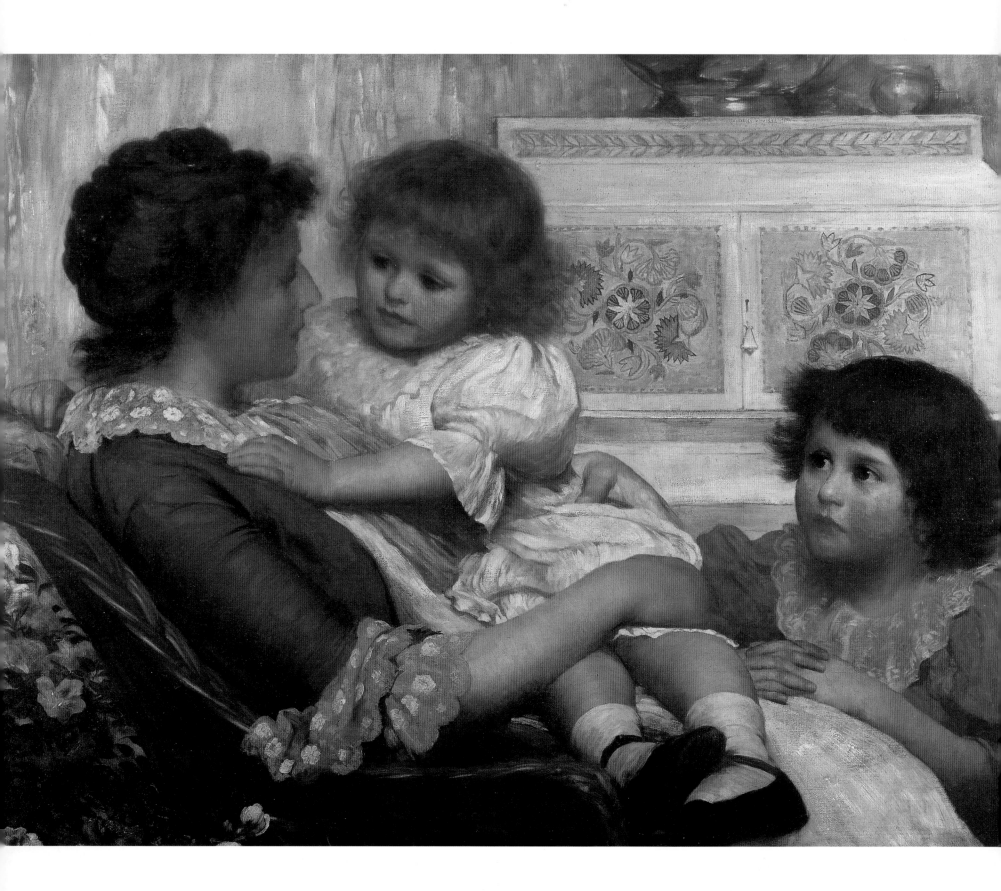

. . . the word most common to children's speech,

most often called out, most repeated for comfort, is "Mommy."

I have never known a mother to feel besmirched by this—

harassed, yes; but degraded? Nonsense.

SONIA JOHNSON (B. 1936)

AMERICAN ACTIVIST, WRITER AND LECTURER

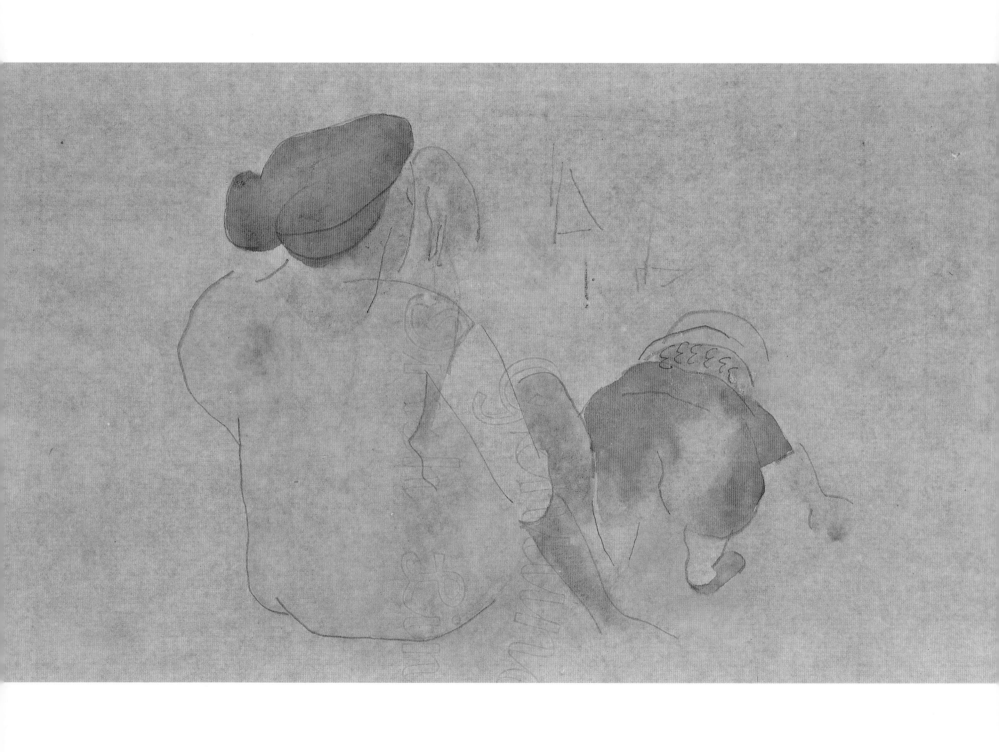

A woman does not have to be a biological mother in order to be

an initiate into the maternal aspect of the Goddess; it comes

through her own embodied maternal and feminine nature. . . .

Jean Shinoda Bolen (b. 1936)
American analyst, educator, and writer

Not flesh of my flesh,

nor bone of my bone but still miraculously

My Own

Don't ever forget, even for one single minute,

you didn't grow under my heart . . .

But in it.

Anonymous

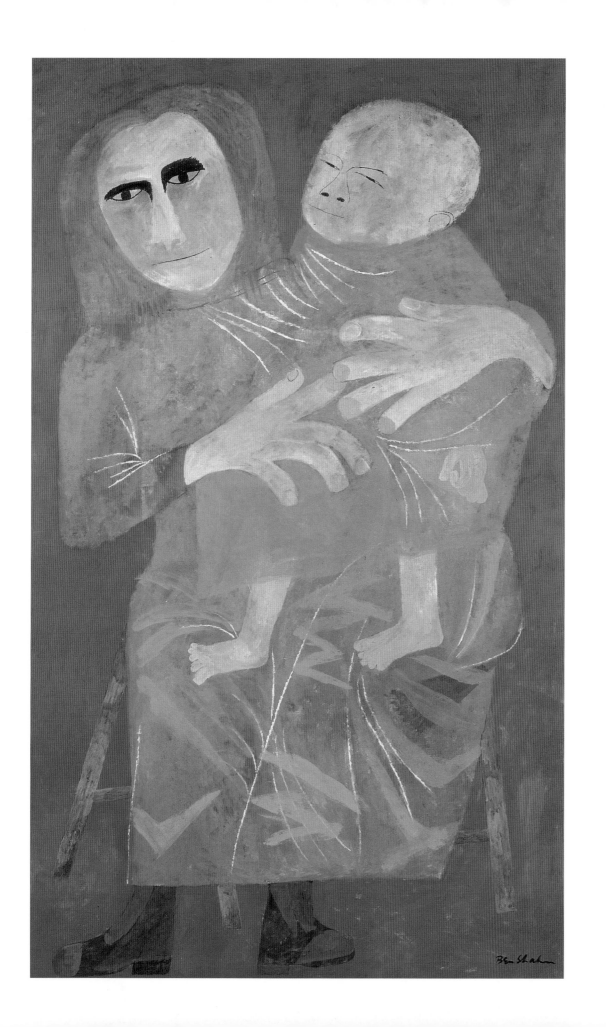

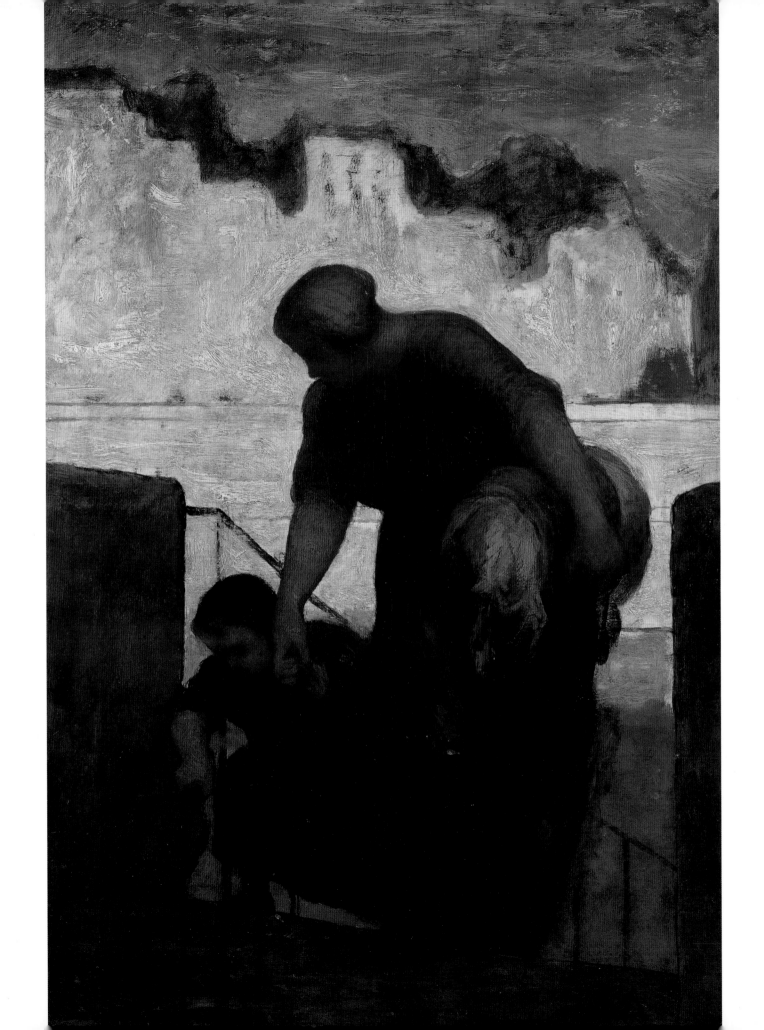

The pleasure of being a parent isn't reasonable or objective . . . it is the extraordinary experience of having short people who hang around a while, who can change you as they change, who push and prod and aggravate and thrill you and make life fuller. Who are, more than anything else, irrationally special to you.

∽

Ellen Goodman (b. 1941)

American writer

What feeling is so nice as a child's hand in yours?

So small, so soft and warm, like a kitten huddling in the shelter of your clasp.

Marjorie Holmes (b. 1910)

American writer

IN A CHILD'S LUNCH BOX,

A MOTHER'S THOUGHTS.

Japanese proverb

You could always separate people who have young children

from those who don't by looking at their refrigerator doors.

Joy Fielding (b. 1945)

Canadian writer

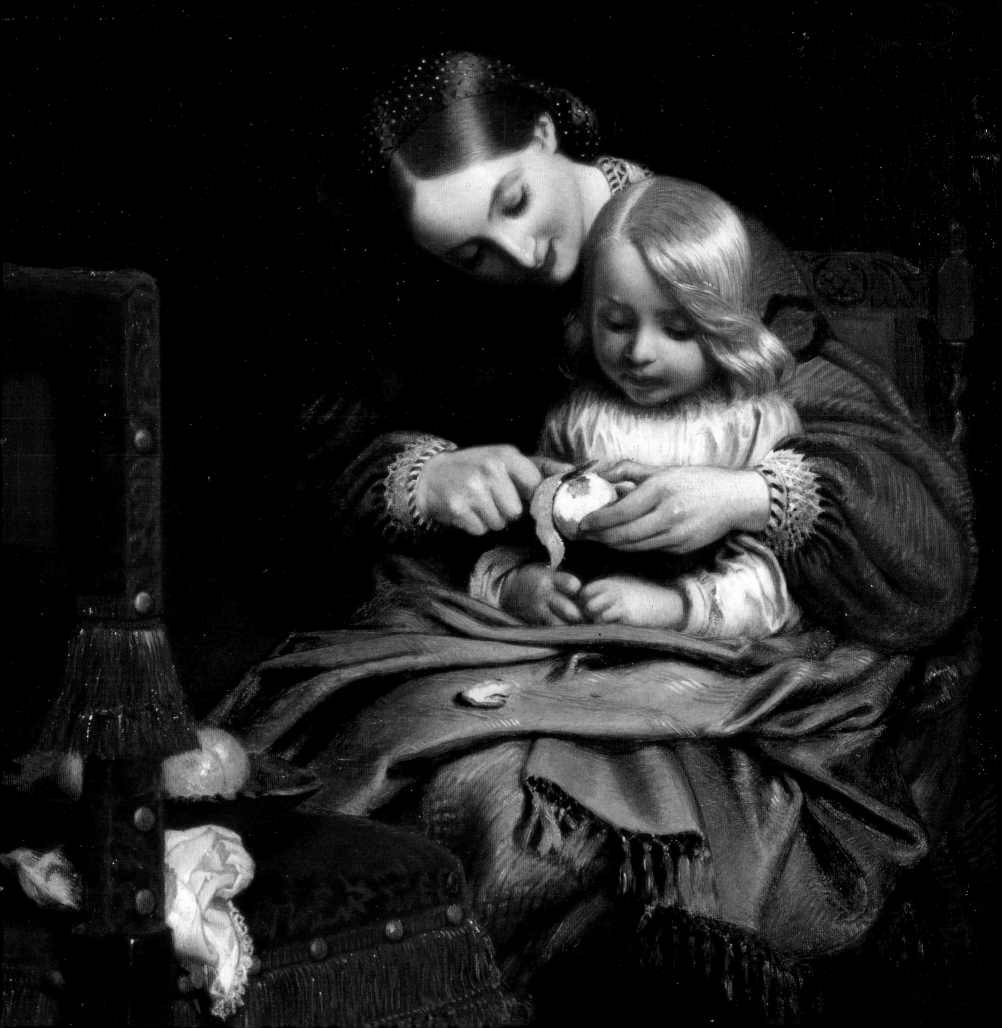

. . . the real achievement of motherly love lies not in the mother's love

for the small infant, but in her love for the growing child.

Erich Fromm (1900–1980)

American psychoanalyst

W ho wouldn't have eighteen children

if it weren't a question of buying them shoes?

Amanda Cross (b. 1926)

American writer

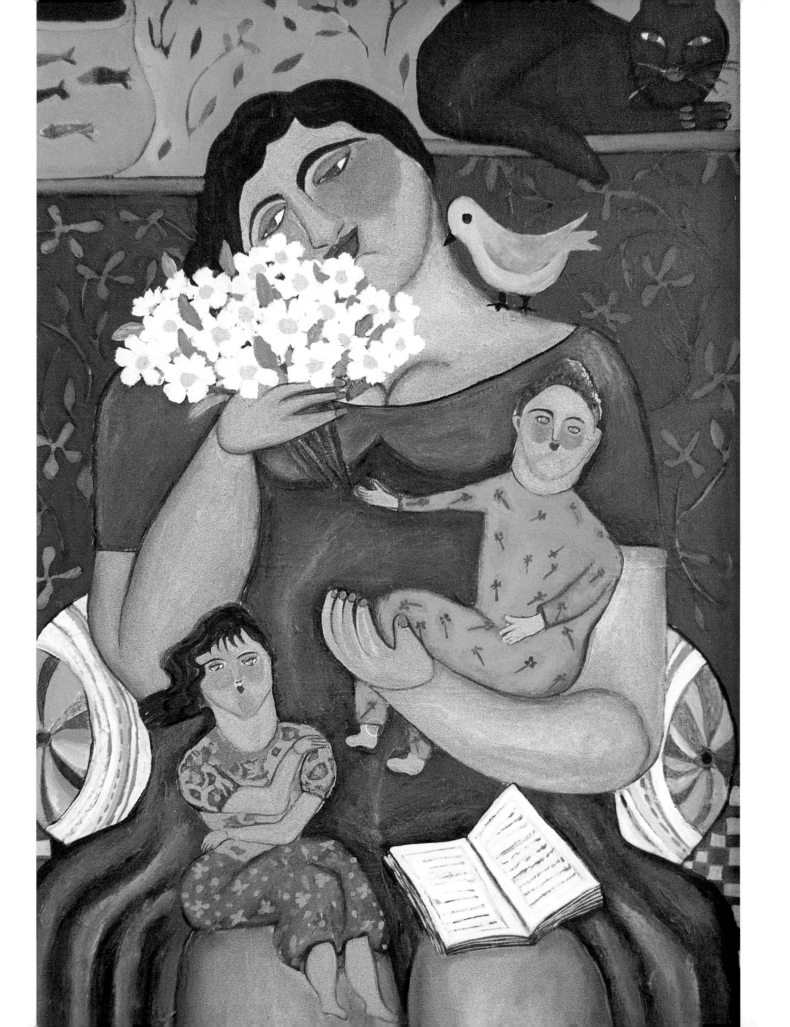

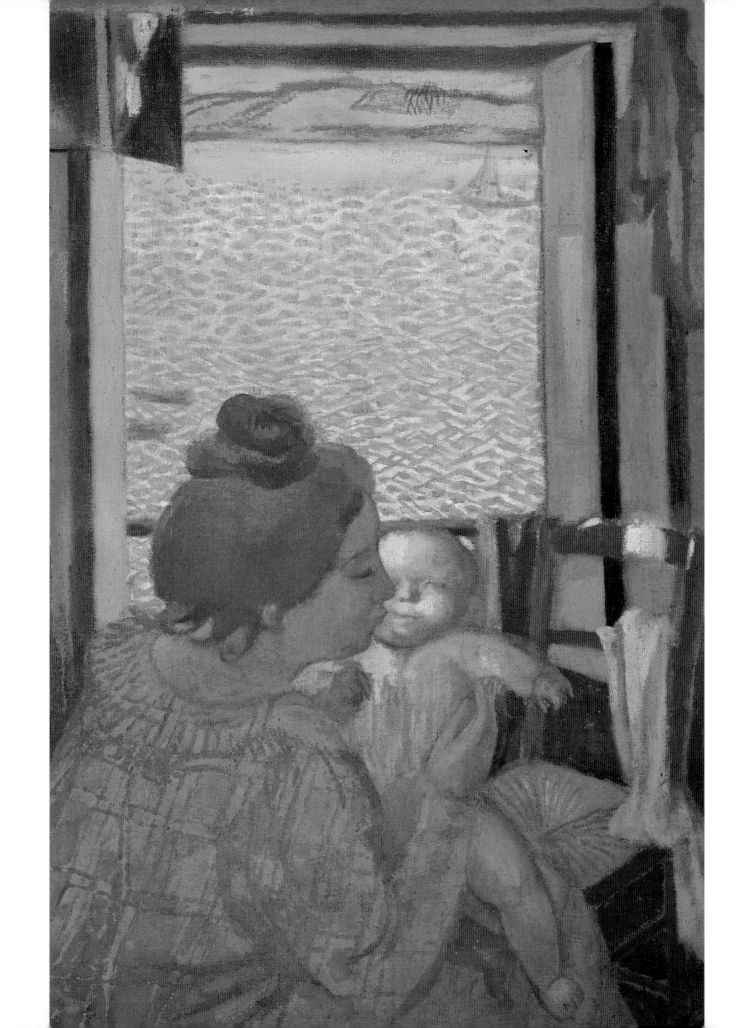

. . . Women know

The way to bring up children (to be just);

They know a simple, merry, tender knack

Of tying sashes, fitting baby shoes,

And stringing pretty words that make no sense,

And kissing full sense into empty words;

Which things are corals to cut life upon,

Although such trifles.

Elizabeth Barrett Browning (1806–1861)

English poet

When a child, my mother taught me the legends of our people;

taught me of the sun and sky,

the moon and stars, the clouds and storms.

Geronimo [Goyathlay] (1829–1909)

Chiricahua Apache chief

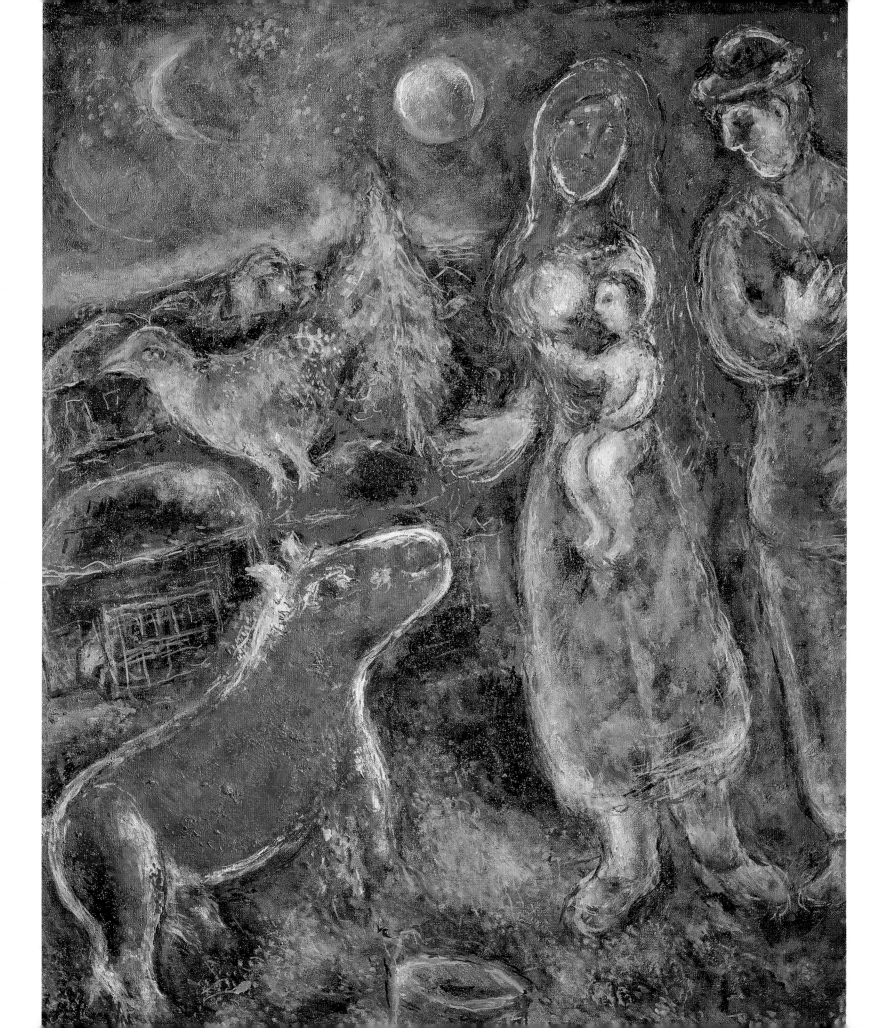

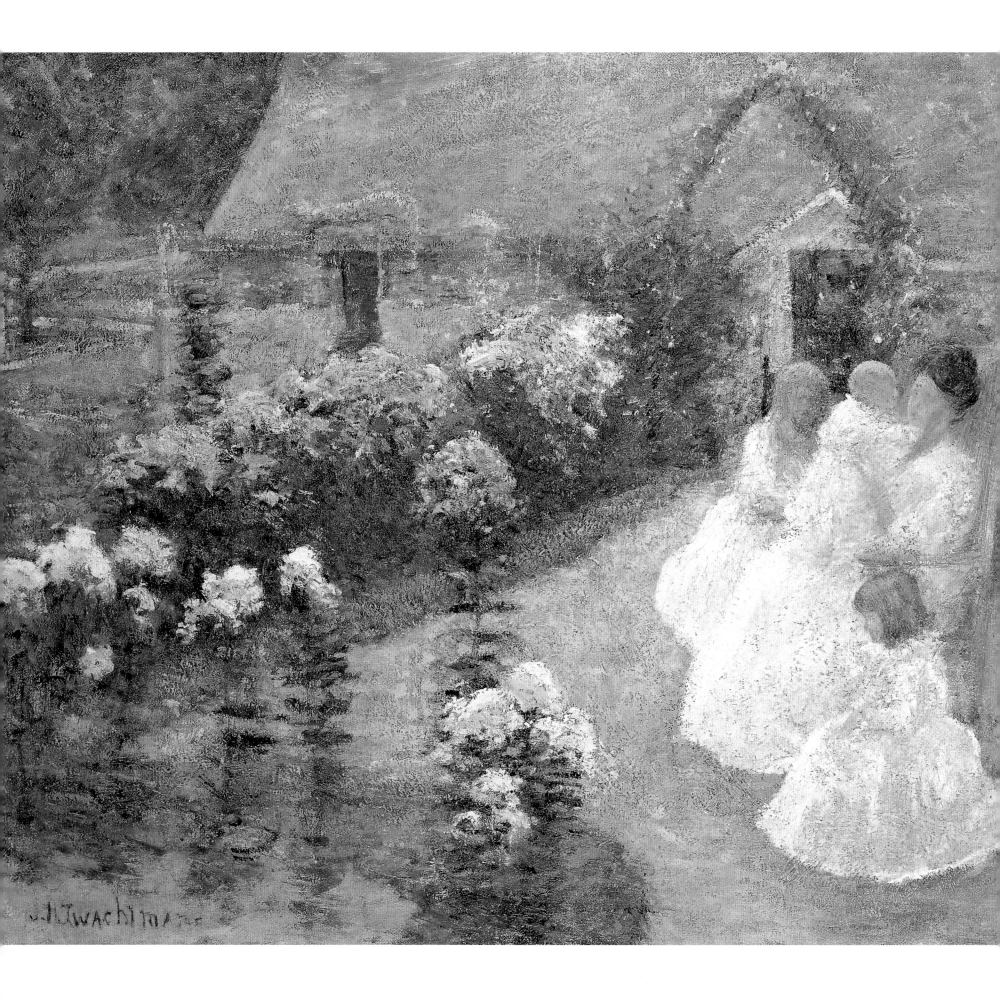

We spent our formative years

marveling at the lovely woman who recited the dreams of egrets and herons,

who could summon moons, banish suns to the west,

then recall a brand-new sun the following morning from far beyond

the breakers of the Atlantic.

Pat Conroy
American writer

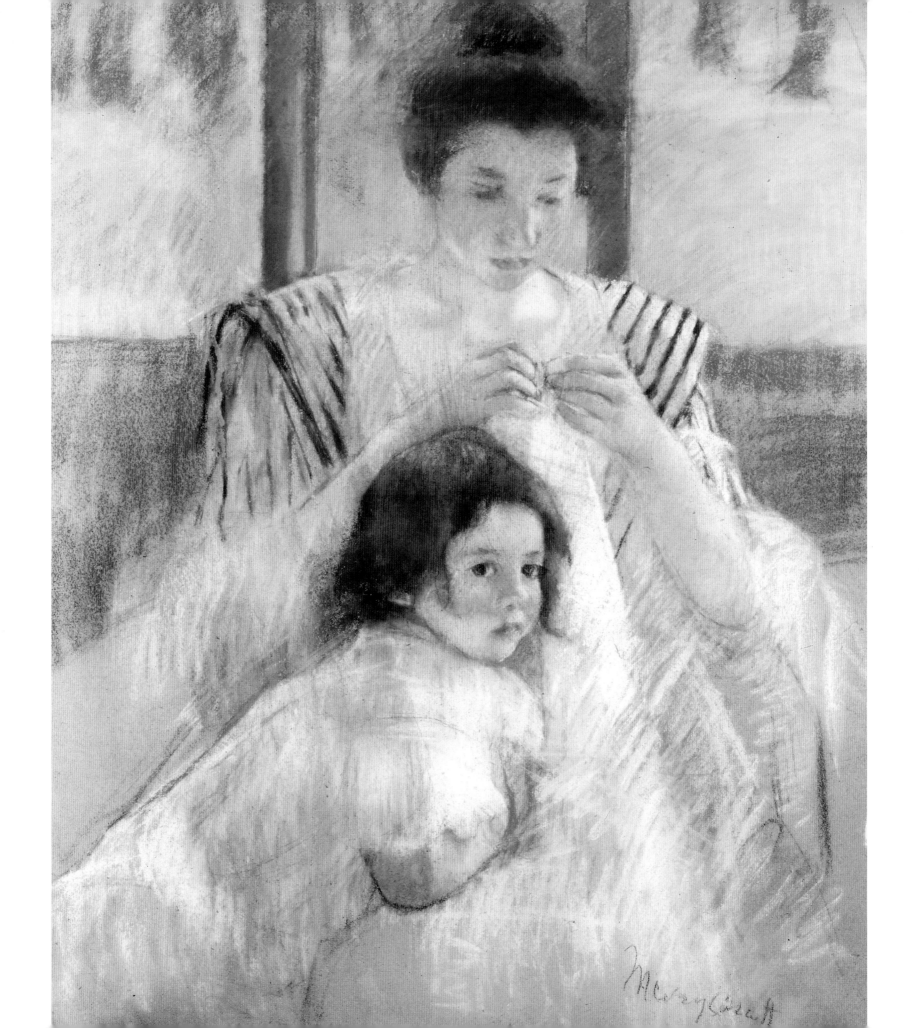

little girl's mother made the quilt to keep her warm

when the snow came down. . . .

She stitched the quilt by a yellow flame,

humming all the time.

She stitched the tails of falling stars.

Tony Johnston
from _The Quilt Story_

When my daughter was born,
one of the unheralded joys of motherhood
was that I finally had a legitimate excuse
for buying toys.

Sarah Ban Breathnach
American writer

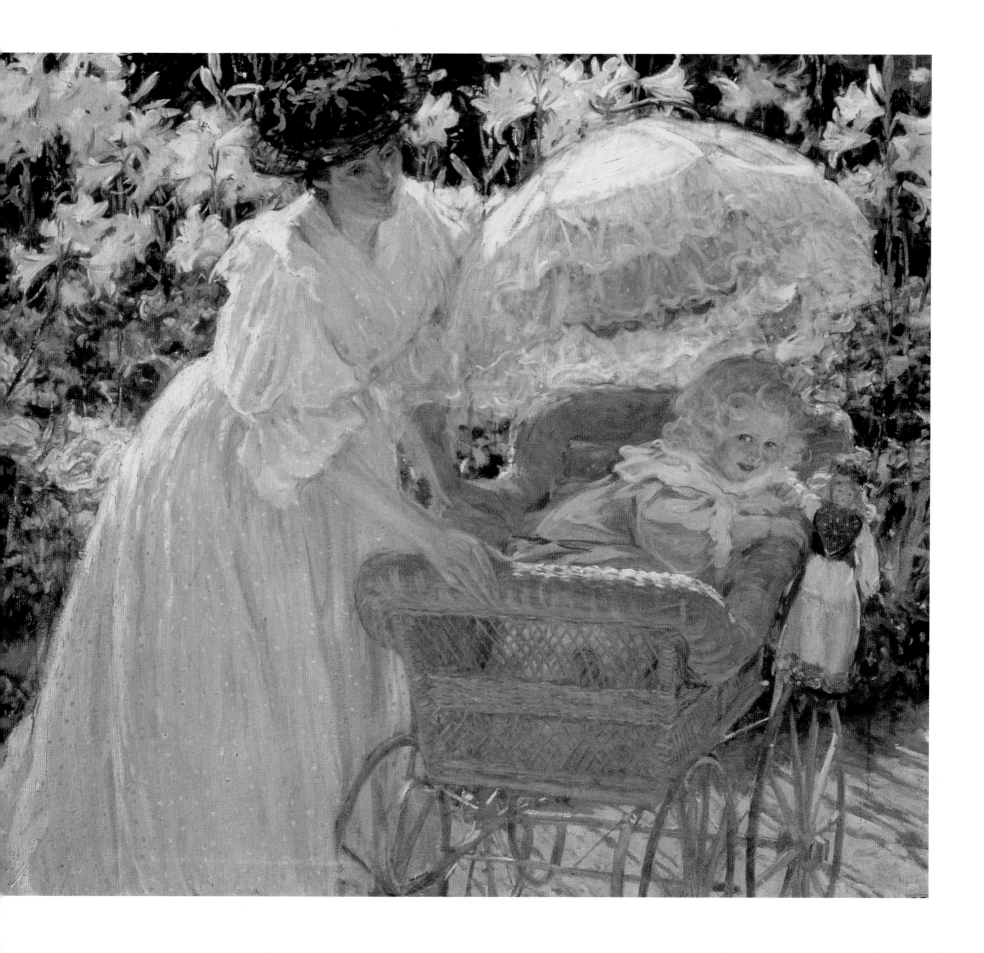

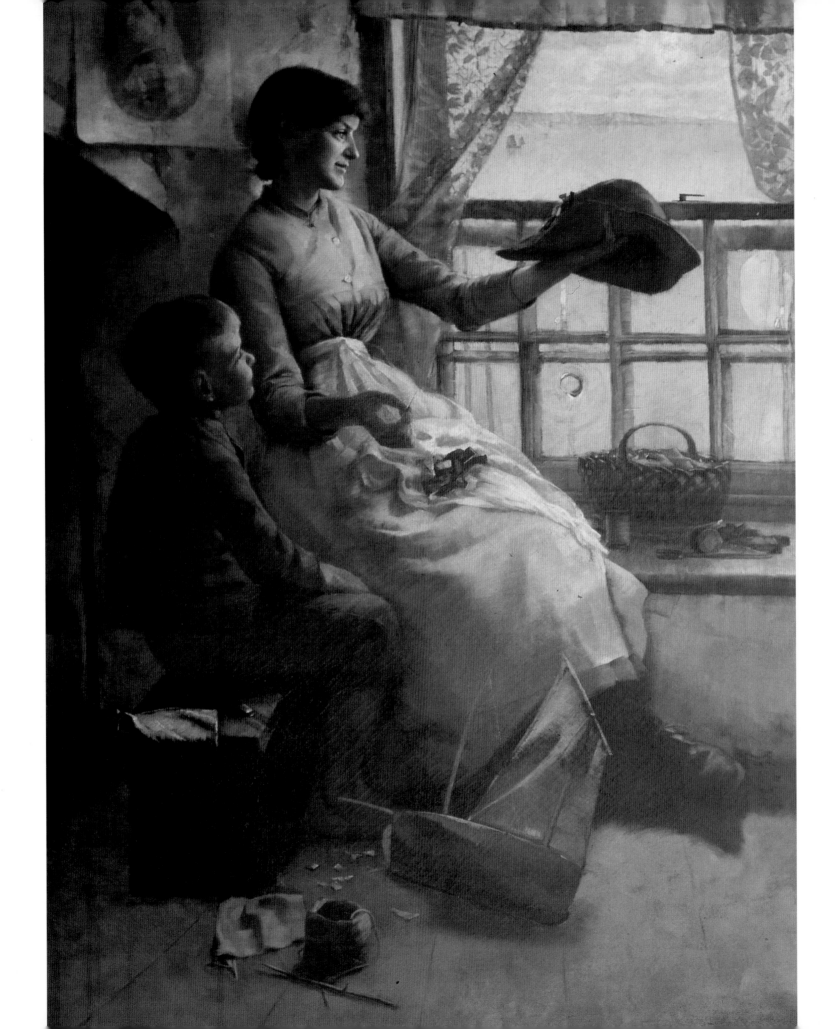

And as any mother can tell you,

whatever your son wants, this is what you want.

You want him to have whatever it takes to make him happy,

above all else in the world.

Lee Smith (b. 1944)

American writer

. . . those babies in my arms, at my breast,

clutching my hands, pulling on my hair, teething on

my heart, tugging at my sleeve, one child in the

stroller, one helping me push, ceaselessly absorbing

all my loyalty and love—those children redefined

every question of bravery, courage, and independence.

Alix Kates Shulman (b. 1932)
American writer

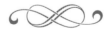

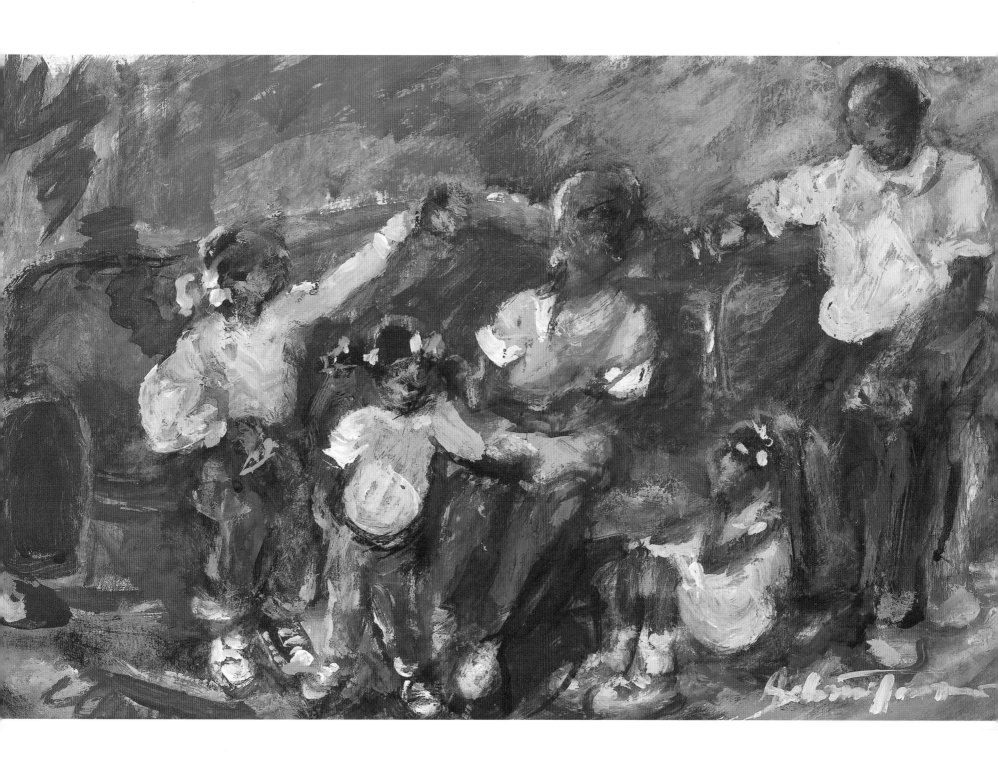

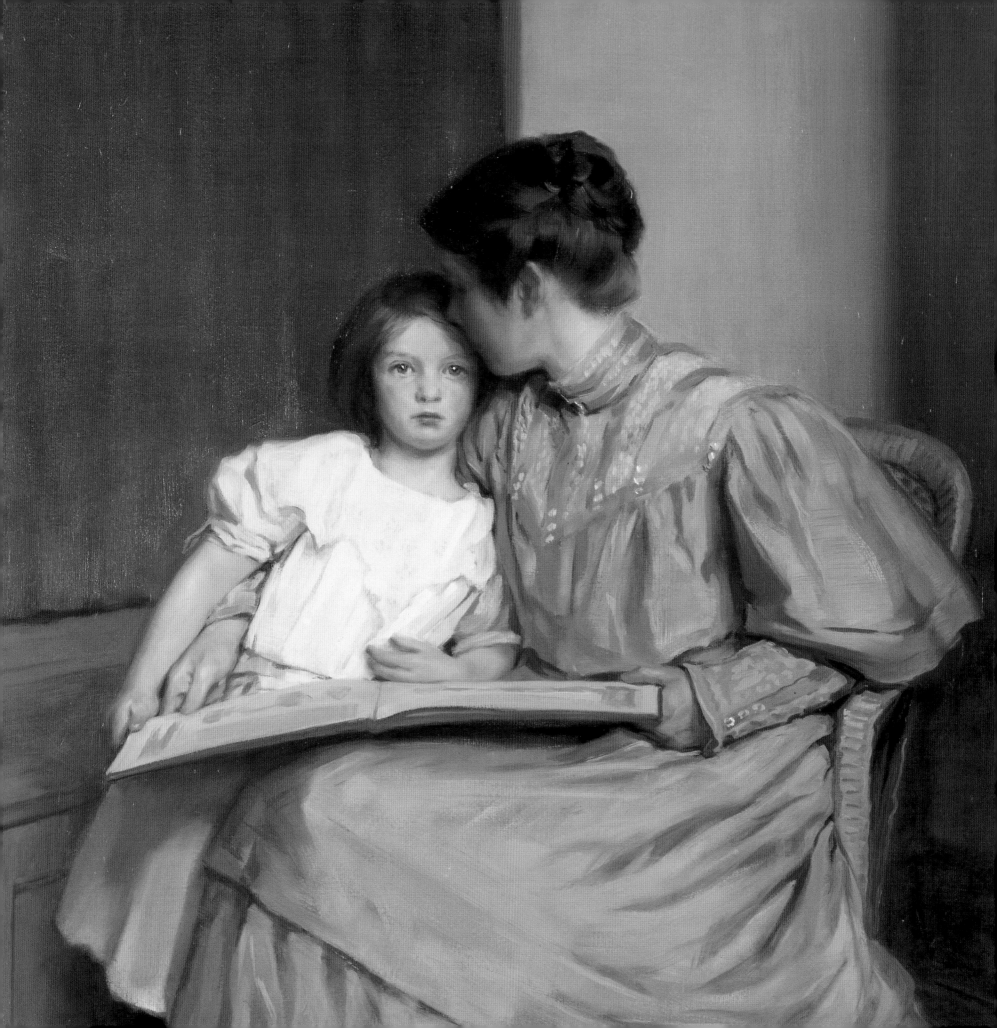

No one has yet fully realized the wealth of sympathy, kindness, and generosity

hidden in the soul of a child.

Emma Goldman (1869–1940)

Russian-born American

lecturer, editor, and activist

IT'S GOOD FOR A CHILD TO LOSE

AS WELL AS WIN.

THEY MUST LEARN IN LIFE THEY ARE

GOING TO BE UP TODAY

AND MAYBE DOWN TOMORROW.

Ruby Middleton Forsythe

Writer

My mother is not like anybody.

She can do things and she knows things. But sometimes she is afraid. I am afraid

too, but my mother thinks I am never afraid,

so I do not tell her . . .

I am not afraid when I am with my mother.

Mary Gordon (b. 1949)

American writer

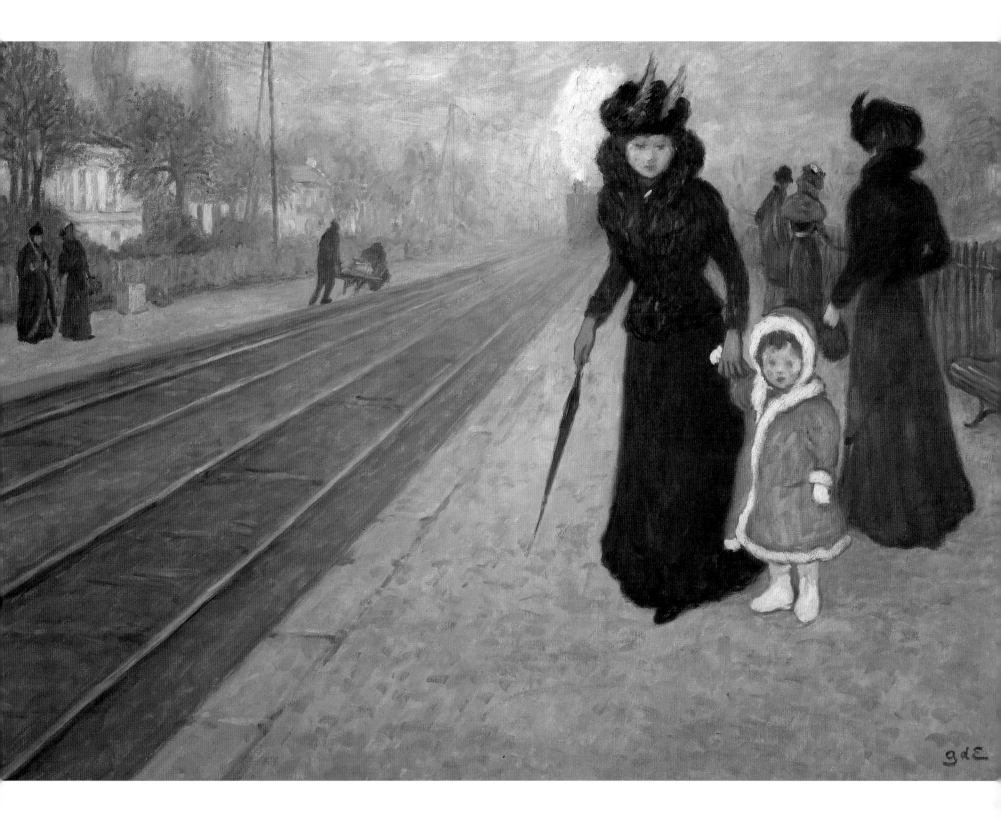

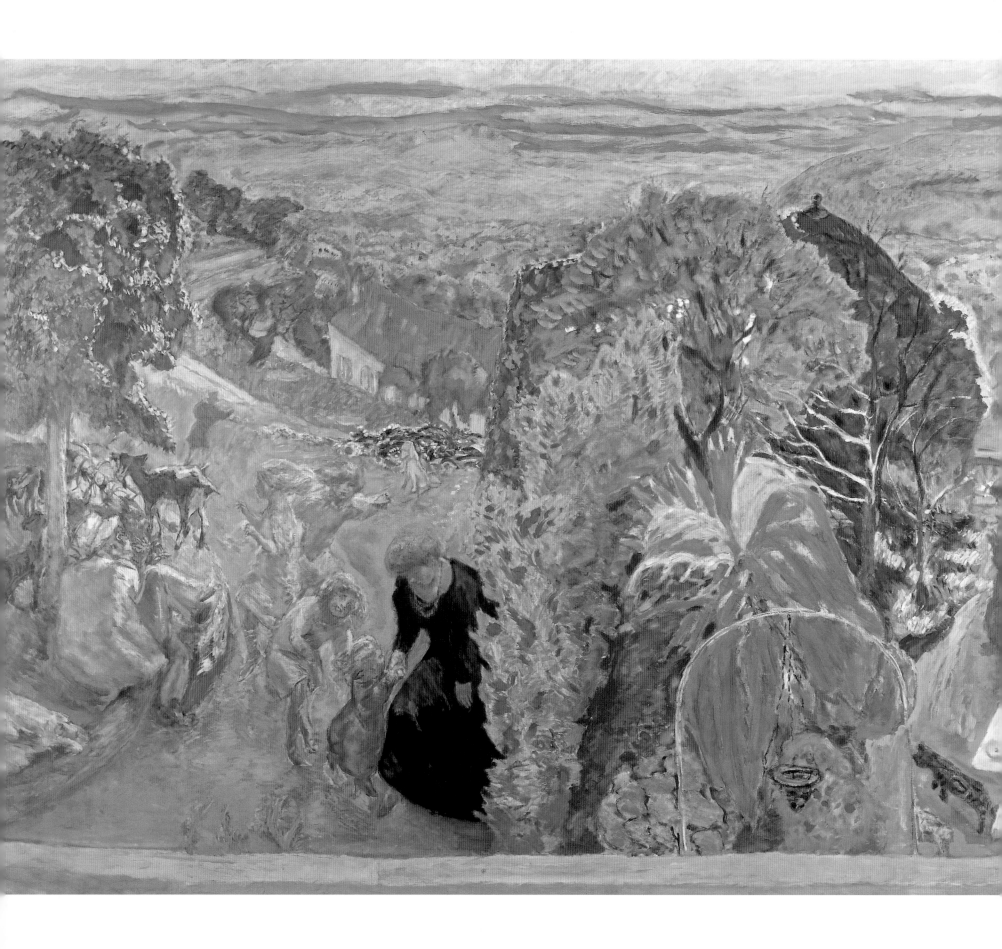

MAMA EXHORTED HER CHILDREN

AT EVERY OPPORTUNITY TO "JUMP AT DE SUN."

WE MIGHT NOT LAND ON THE SUN,

BUT AT LEAST WE WOULD GET OFF THE GROUND.

Zora Neale Hurston (c. 1901–1960)
American anthropologist and writer

THEY ALWAYS LOOKED BACK BEFORE TURNING THE CORNER, FOR THEIR MOTHER WAS ALWAYS AT THE WINDOW TO NOD AND SMILE, AND WAVE HER HAND AT THEM. SOMEHOW IT SEEMED AS IF THEY COULDN'T HAVE GOT THROUGH THE DAY WITHOUT THAT, FOR WHATEVER THEIR MOOD MIGHT BE, THE LAST GLIMPSE OF THAT MOTHERLY FACE WAS SURE TO AFFECT THEM LIKE SUNSHINE.

Louisa May Alcott (1832–1888)
American writer

We don't achieve to be accepted by our families.

We just have to be. Our membership is not based on

credentials but on birth.

Ellen Goodman
American writer

Grown don't mean nothing to a mother.

A child is a child. They get bigger, older, but grown?

What's that supposed to mean?

In my heart it don't mean a thing.

Toni Morrison
American writer

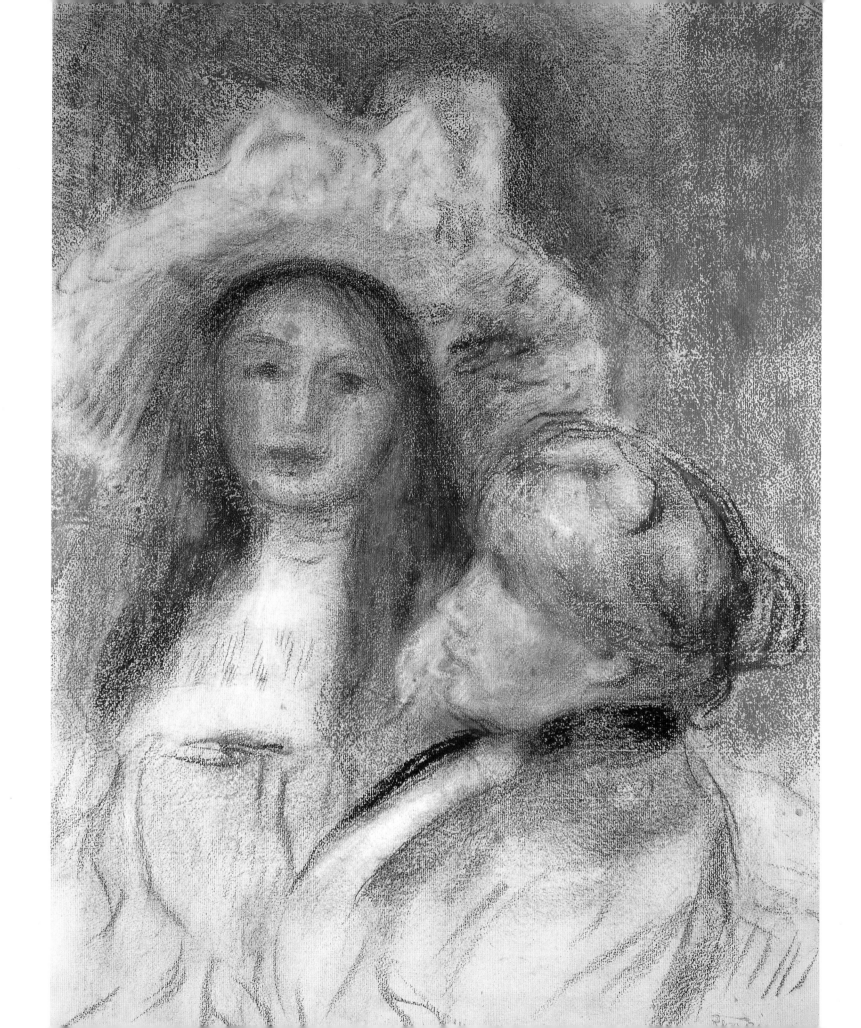

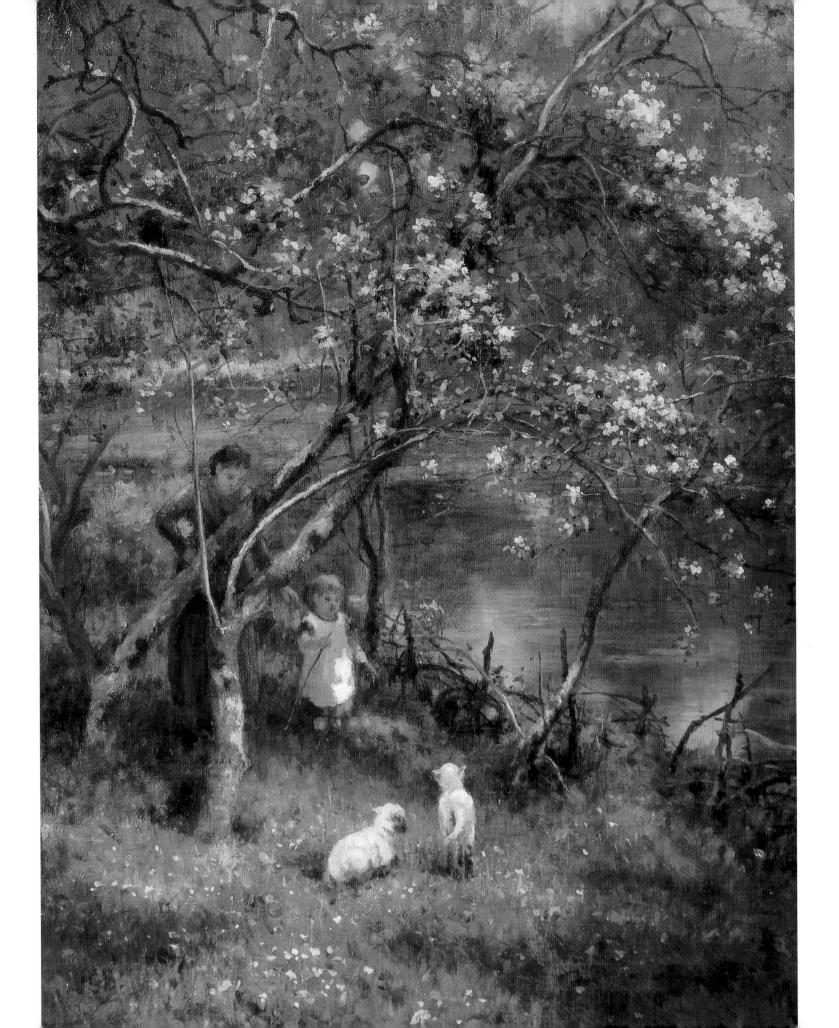

ut kids don't stay with you if you do it right.

It's one job where, the better you are,

the more surely you won't be needed in the long run.

Barbara Kingsolver (b. 1955)

American writer

And you must tell the child

THE LEGENDS I TOLD YOU—AS MY MOTHER TOLD THEM

TO ME AND HER MOTHER TO HER.

YOU MUST TELL THE FAIRY TALES OF THE OLD COUNTRY.

YOU MUST TELL OF THOSE NOT OF THE EARTH

WHO LIVE FOREVER IN THE HEARTS OF PEOPLE.

Betty Smith
American writer

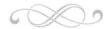

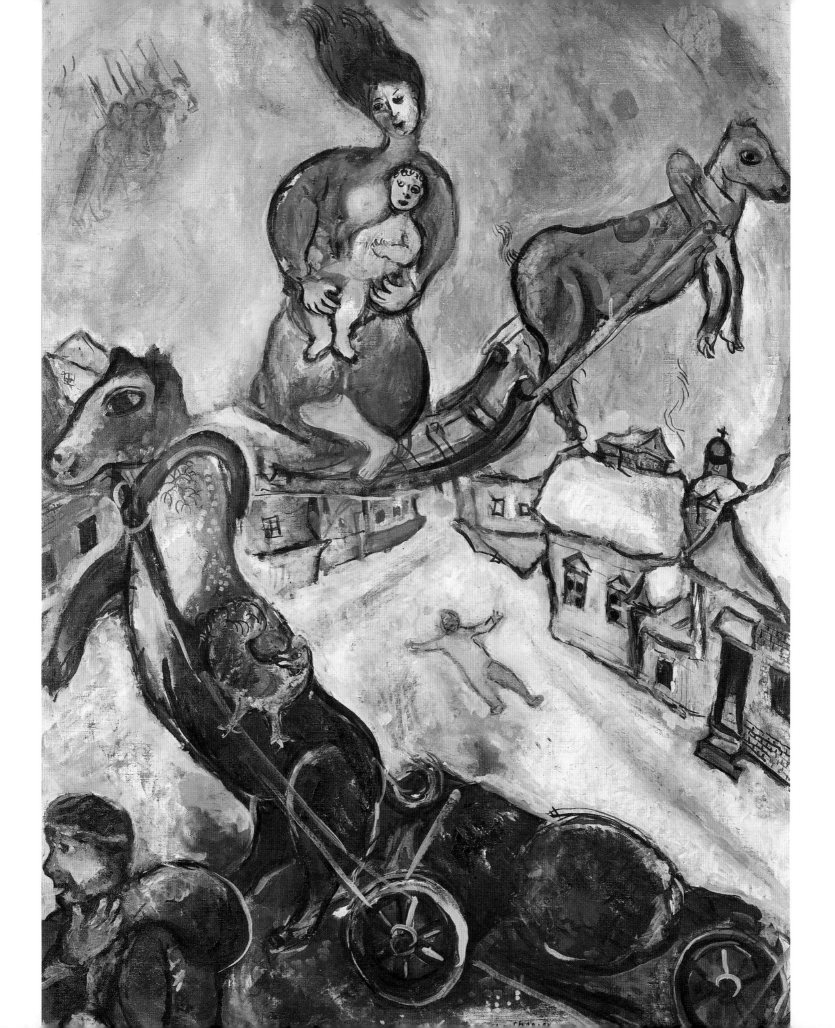

I am my mother's

daughter . . .

and although it's been

twenty years since

I left home,

her sayings form

a perpetual long-playing

record on my

inner-ear turntable.

CAROL SHIELDS (B. 1935)
AMERICAN WRITER

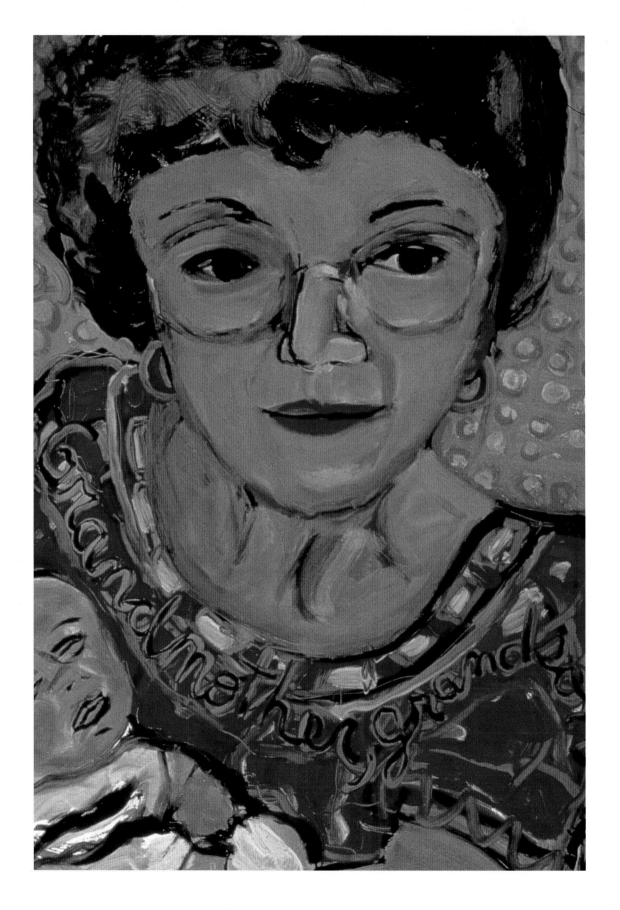

A baby's mother also needs a mother.

ERICA JONG (B. 1942)
AMERICAN WRITER AND POET

You never will finish being a daughter. . . .

You will be one when you're ninety and so will I.

Gail Godwin (b. 1937)

American writer

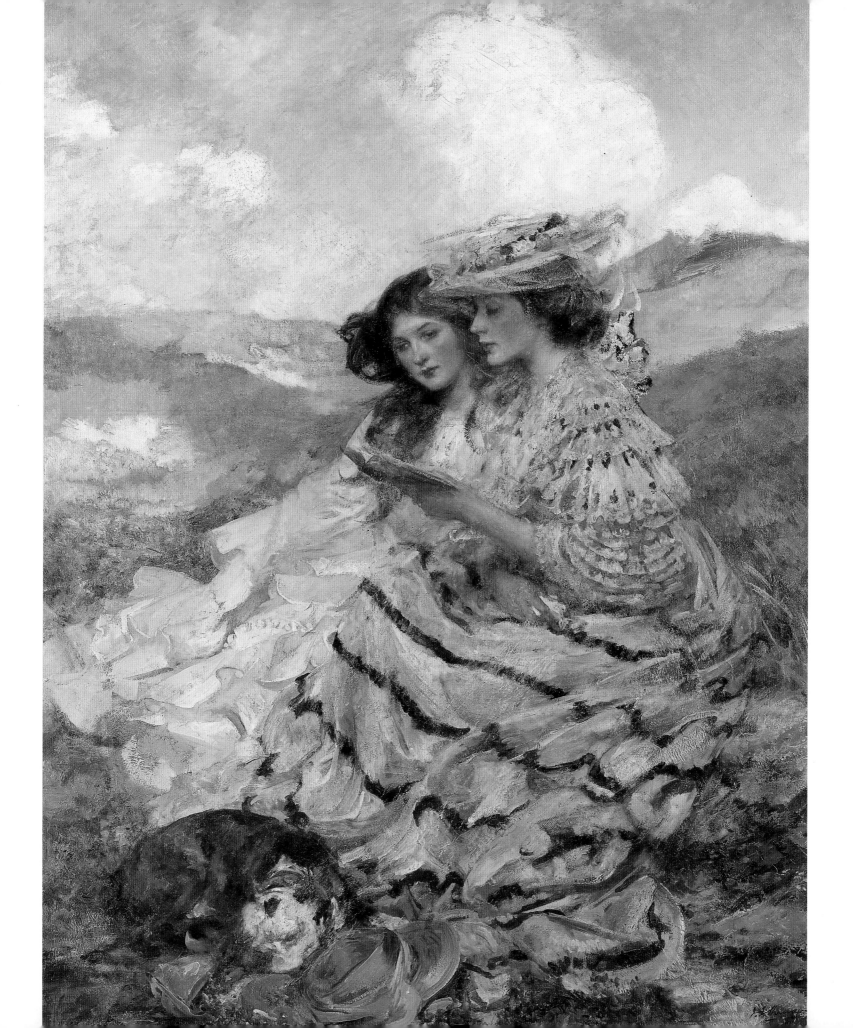

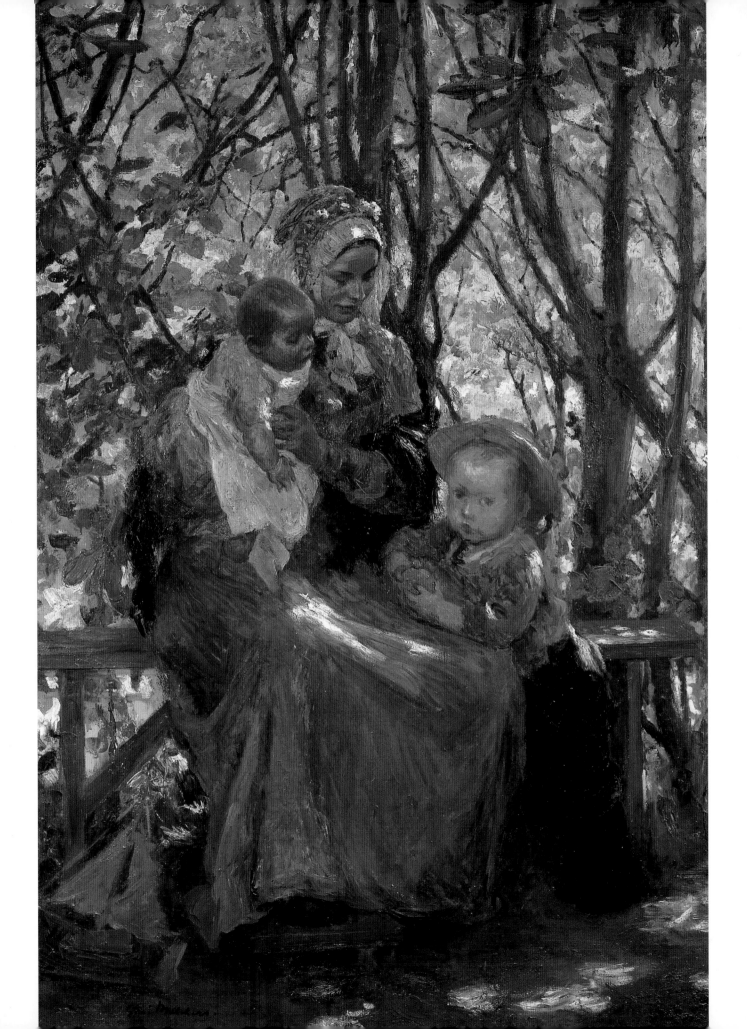

Loving you was easy. People warned me about the terrible twos and the threatening threes and the frightful fours, but you never had them. . . . Seeing you sleeping peacefully on your back among your stuffed ducks, bears, and basset hounds, a glow of fevery red on your cheeks from playing so hard, would remind me that no matter how good the next day might be, certain moments were gone forever because we could not go backwards in time.

Joan Baez (b. 1941)
American folksinger and activist

What could be more astonishing to witness than the growth of her own children from infant enigmas to their complex and definite, yet ever-changing selves.

Elizabeth Cunningham (b. 1953)
American writer

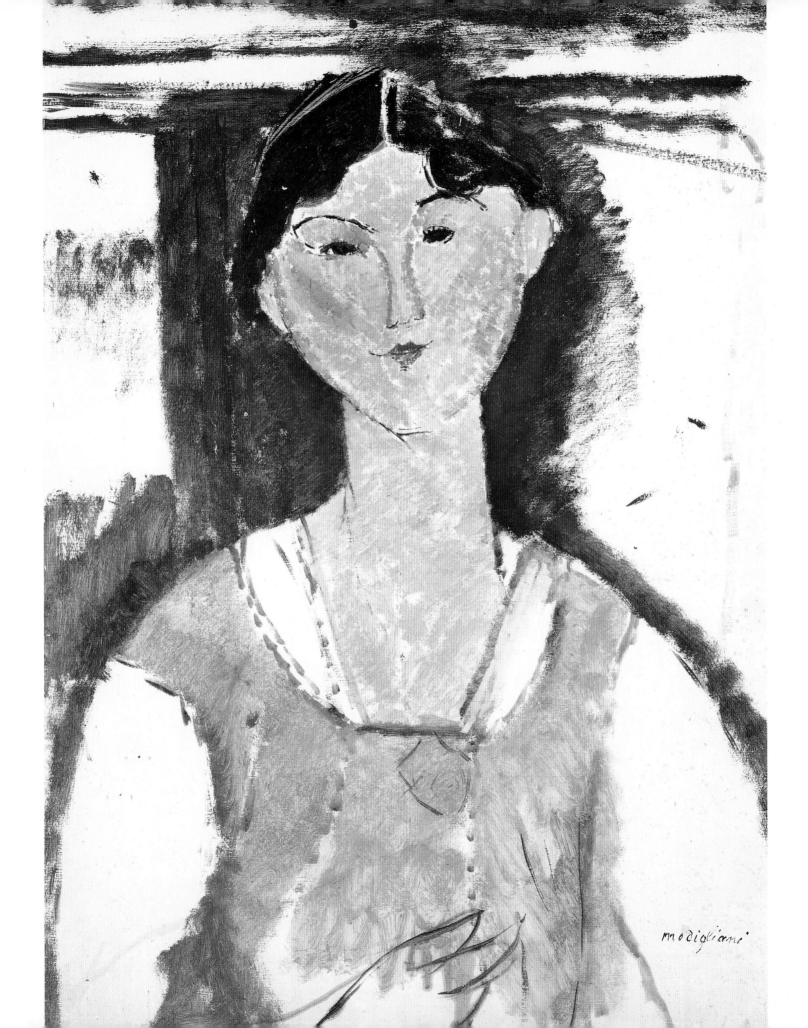

My Mother

To my mother I tell the truth.

I have no thought, no feeling that I cannot share with my mother,

and she is like a second conscience to me,

her eyes like a mirror reflecting my own image.

William Gerhardi (1895–1977)

Writer

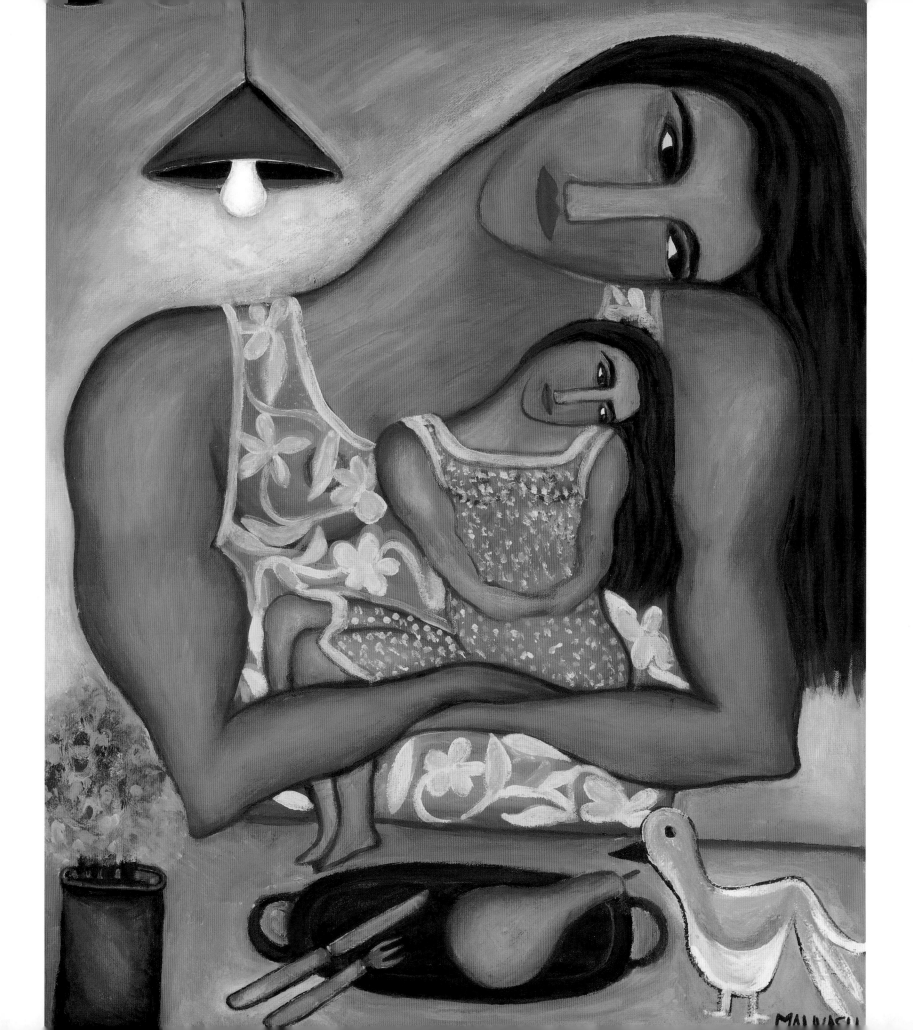

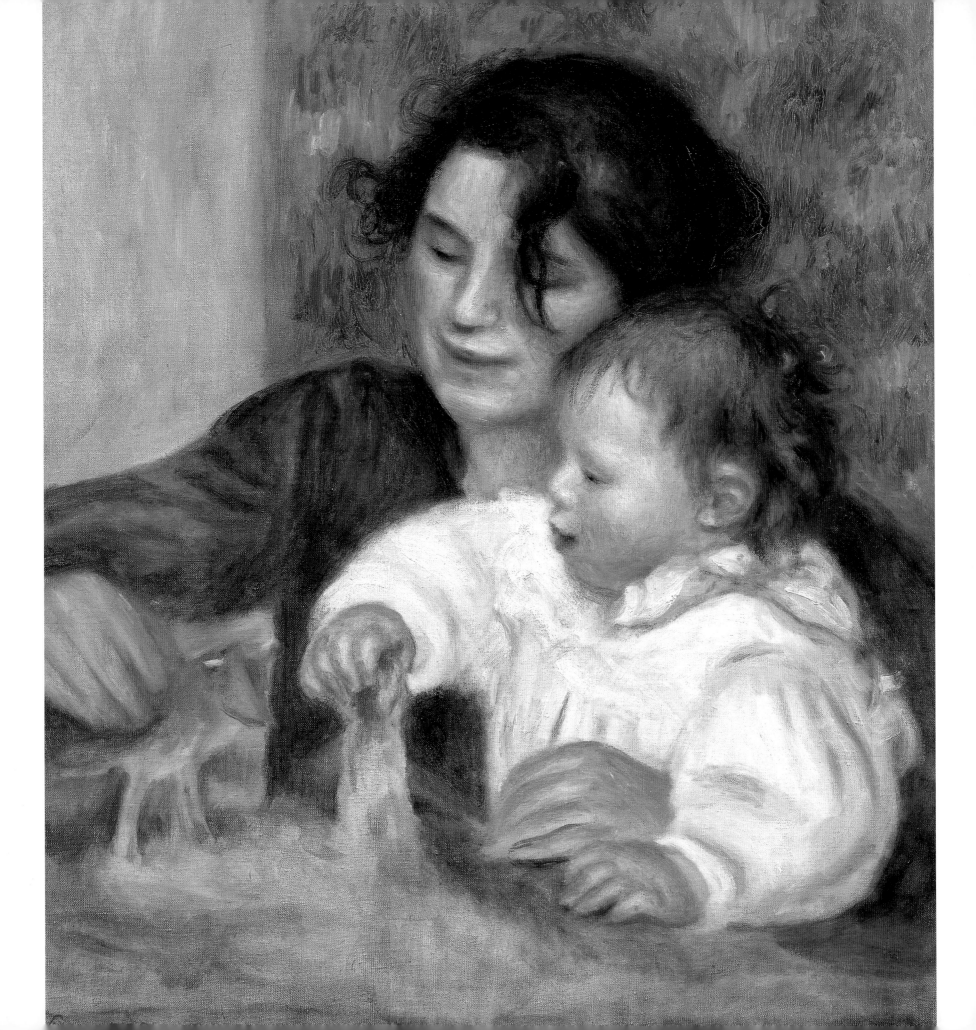

Round the idea of one's mother, the mind of man clings with fond affection.

It is the first thought stamped upon our infant hearts, when yet soft and capable

to receiving the most profound impressions, and all the after feelings of the world

are more or less light in comparison. I do not know that even in our old age

we do not look back to that feeling as the sweetest we have ever known through life.

Charles Dickens (1812–1870)

English writer

My mother had a great deal of trouble with me,

but I think she enjoyed it.

Mark Twain (1835–1910)

American writer

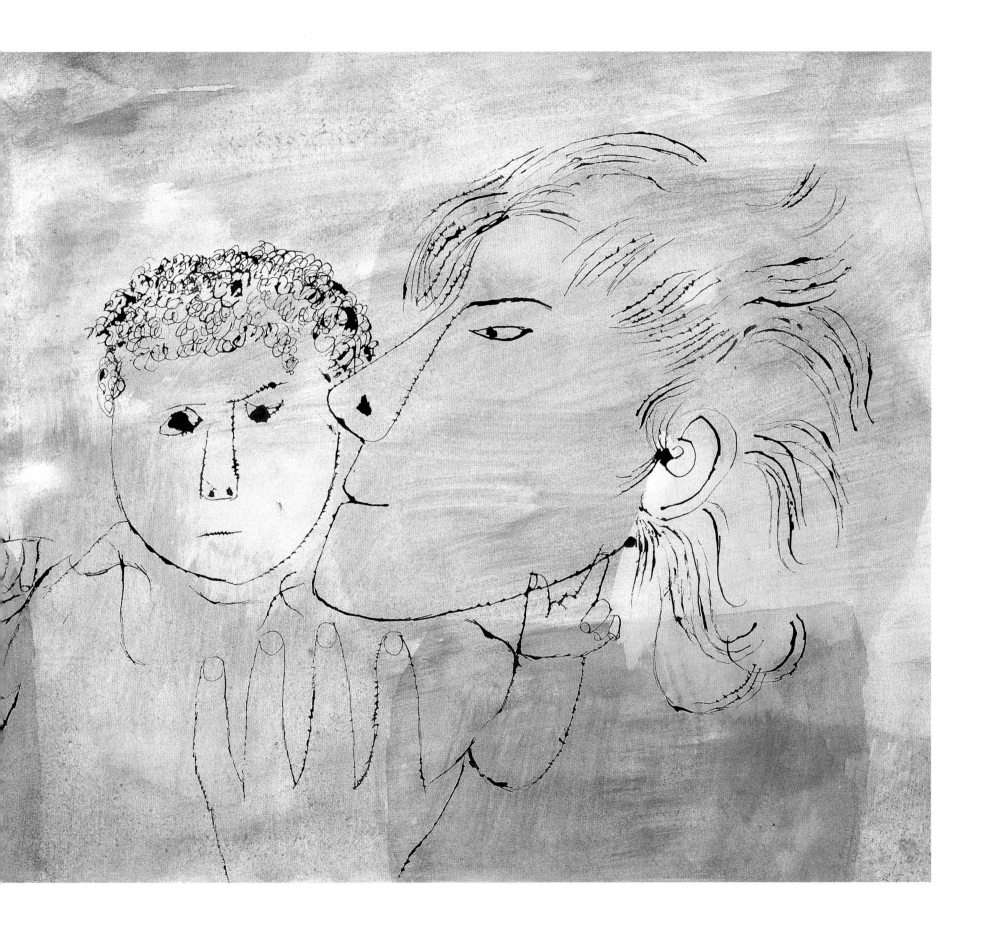

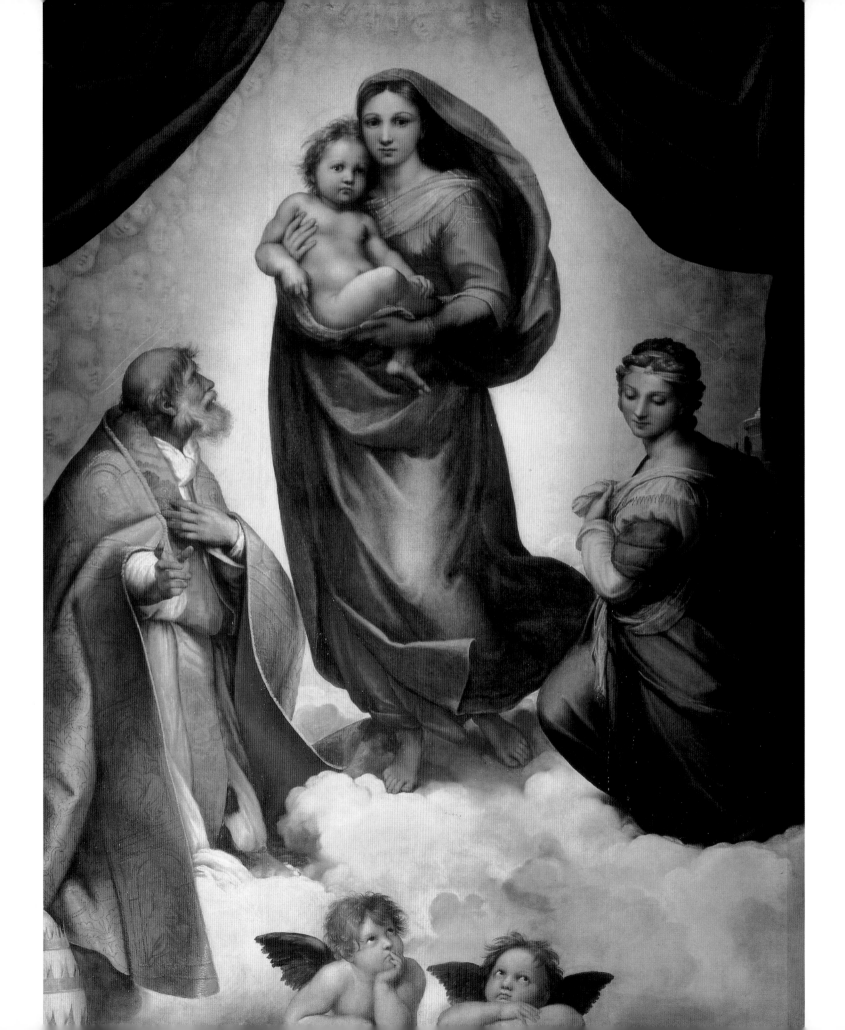

My mother succeeded in making me understand a great deal . . .
indeed I owe to her loving wisdom,
all that was bright and good in my long night.

Helen Keller (1880–1968)
American writer and lecturer

There is an enduring tenderness in the love

of a mother. . . . It is neither to be chilled by selfishness,

nor daunted by danger. . . . She will sacrifice every com-

fort to his convenience; she will surrender every plea-

sure to his enjoyment; she will glory in his fame and

exalt in his prosperity; and if adversity overtake him, he

will be the dearer to her by misfortune; and if disgrace

settle upon his name, she will love and cherish him; and

if all the world beside cast him off, she will be all the

world to him.

Washington Irving (1783–1859)
American writer

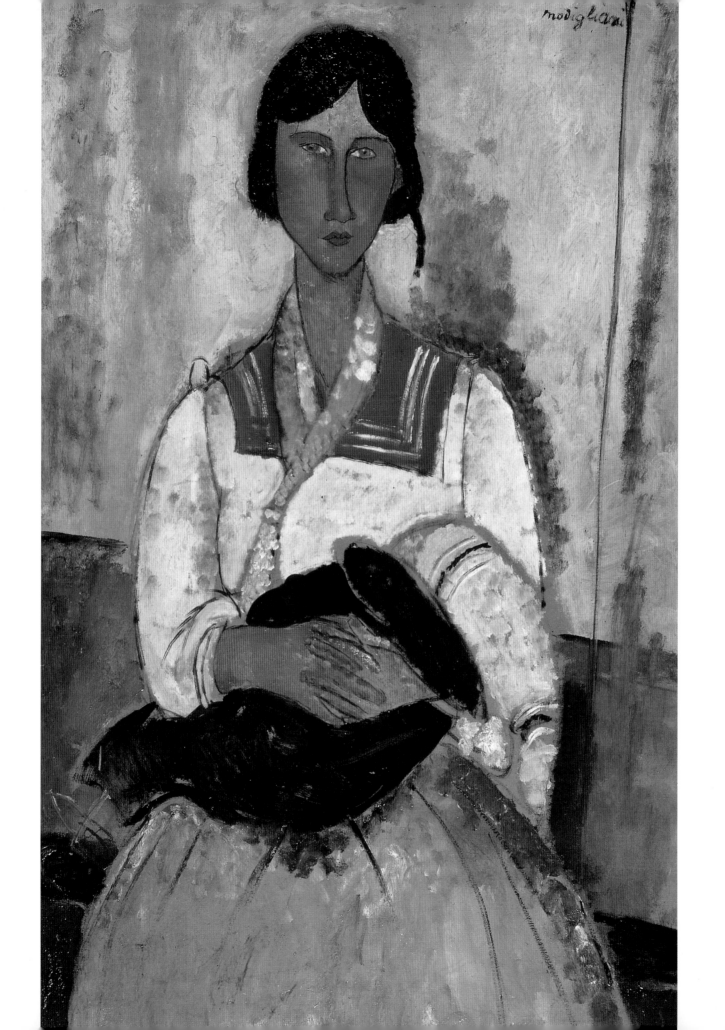

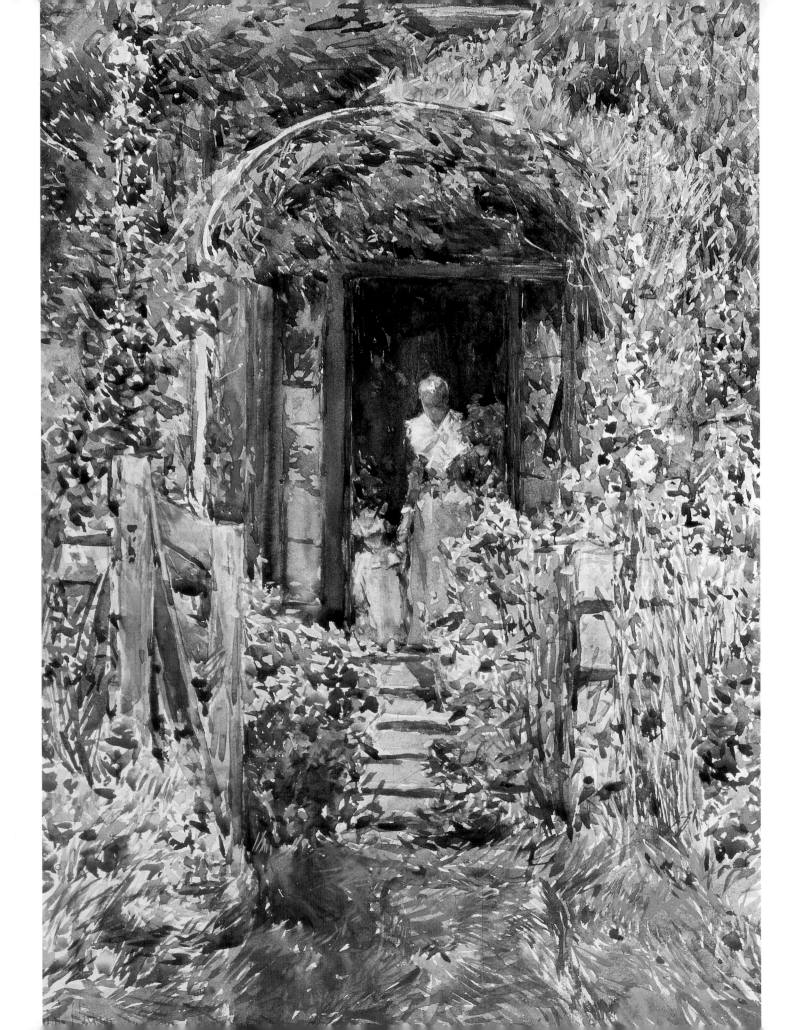

When mamma smiled, beautiful as her face was, it grew incomparably more lovely, and everything around seemed brighter. If in life's sad moments I could but have had a glimpse of that smile I should not have known what sorrow is.

Leo Nikolaievich Tolstoy (1828–1910)
Russian writer

I SHALL NEVER FORGET MY MOTHER,

FOR IT WAS SHE WHO PLANTED AND NURTURED

THE FIRST SEEDS OF GOOD WITHIN ME.

SHE OPENED MY HEART TO THE IMPRESSIONS OF NATURE;

SHE AWAKENED MY UNDERSTANDING AND

EXTENDED MY HORIZON,

AND HER PRECEPTS EXERTED AN EVERLASTING INFLUENCE

UPON THE COURSE OF MY LIFE.

Immanuel Kant (1724–1804)
German philosopher

It was from you that I first learned to think,

to feel, to imagine, to believe. . . .

John Sterling (1806–1844)

English writer and poet

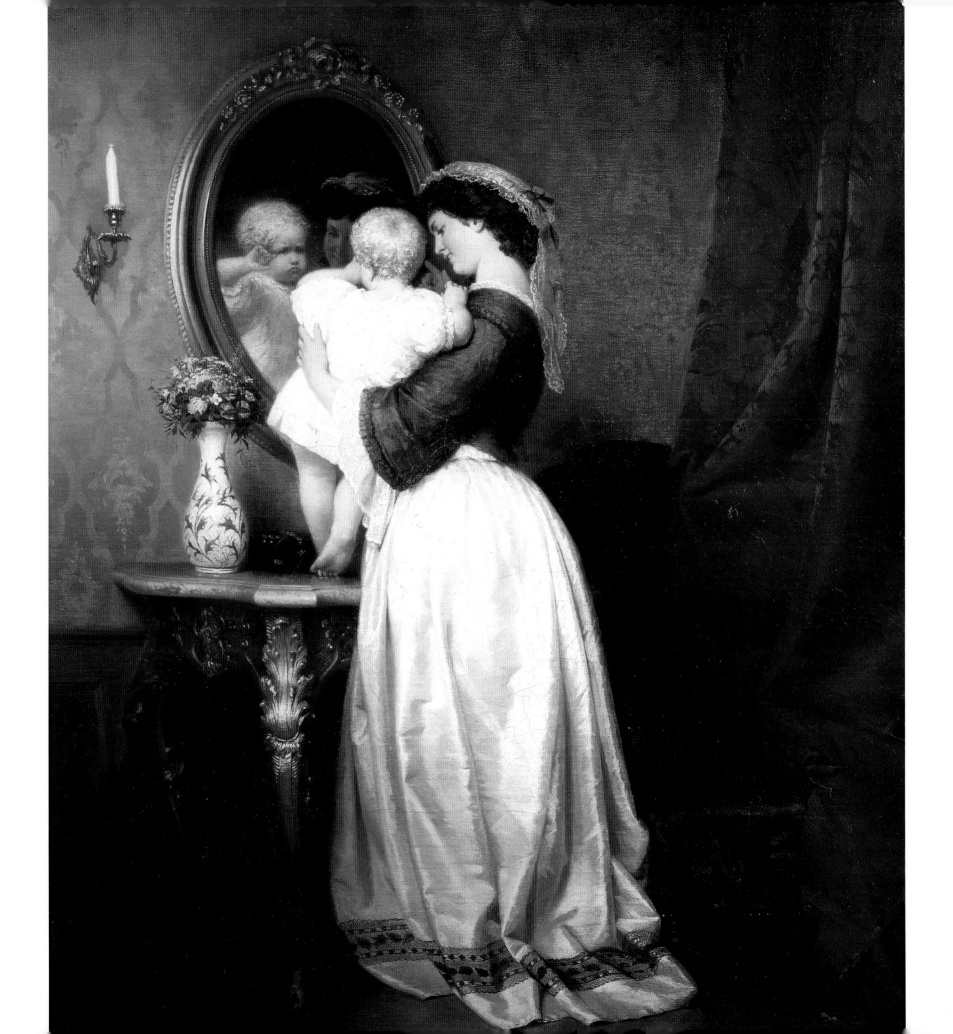

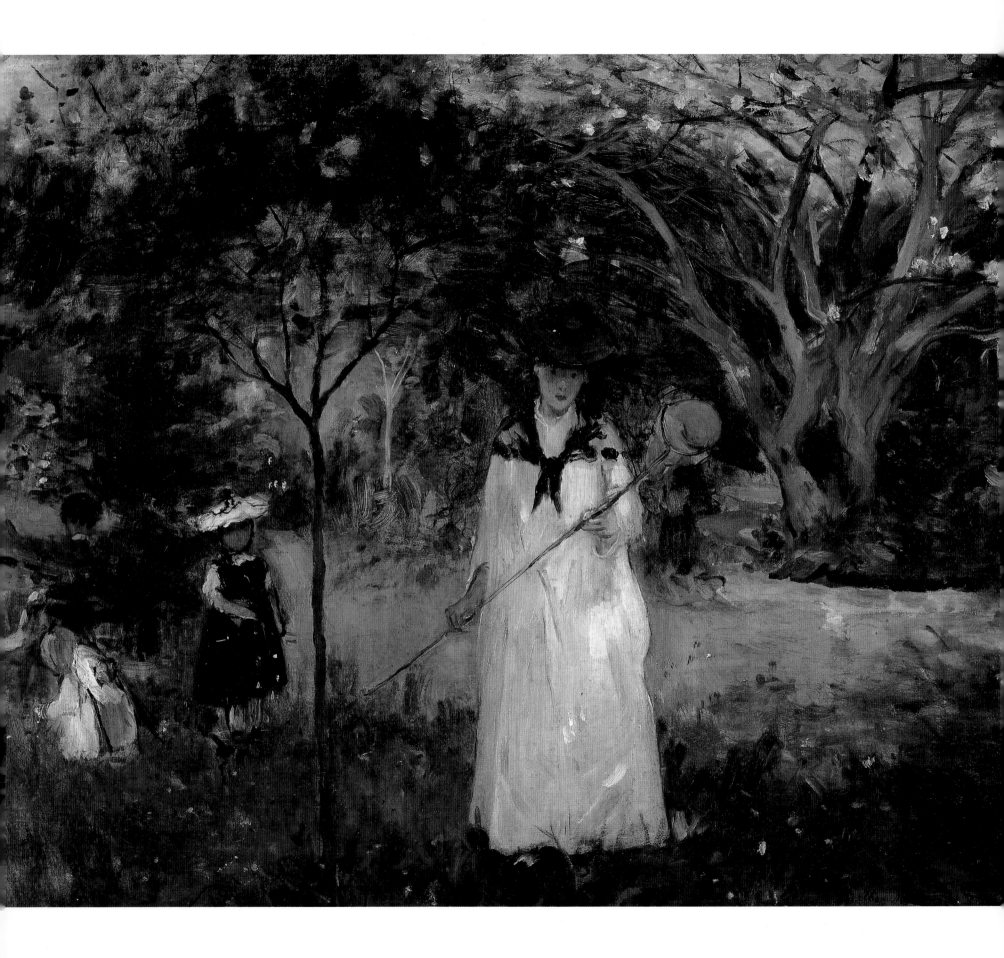

The heart of a mother is a deep abyss

at the bottom of which you will always

discover forgiveness.

Honoré de Balzac (1799–1850)
French writer

IN THE BEGINNING THERE WAS MY MOTHER. A SHAPE. A SHAPE AND A FORCE,

STANDING IN THE LIGHT. YOU COULD SEE HER ENERGY; IT WAS VISIBLE IN THE AIR.

AGAINST ANY BACKGROUND SHE STOOD OUT. . . .

Marilyn Krysl
American writer

S

SHE IS THEIR EARTH. . . .

SHE IS THEIR FOOD AND THEIR BED

AND THE EXTRA BLANKET

WHEN IT GROWS COLD IN THE NIGHT;

SHE IS THEIR WARMTH AND

THEIR HEALTH AND THEIR SHELTER. . . .

Katherine Butler Hathaway
Writer

Who is it that loves me and will love me forever with an affection which no chance,

no misery, no crime of mine can do away? It is you, my mother.

Thomas Carlyle (1795–1881)
Scottish writer and historian

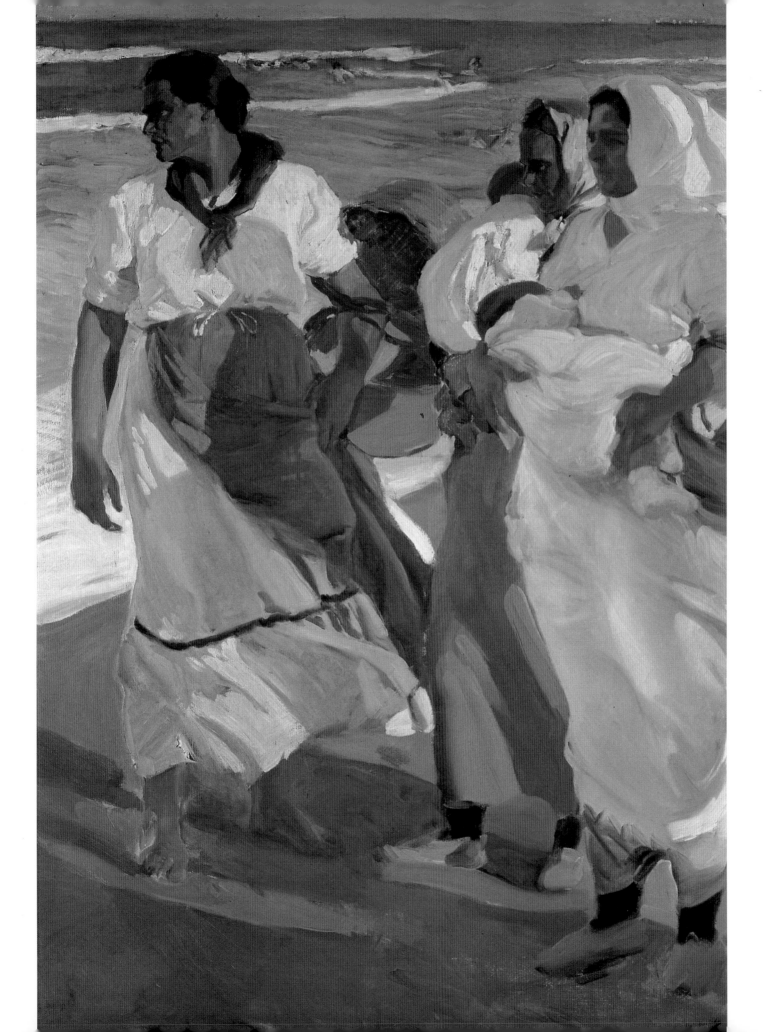

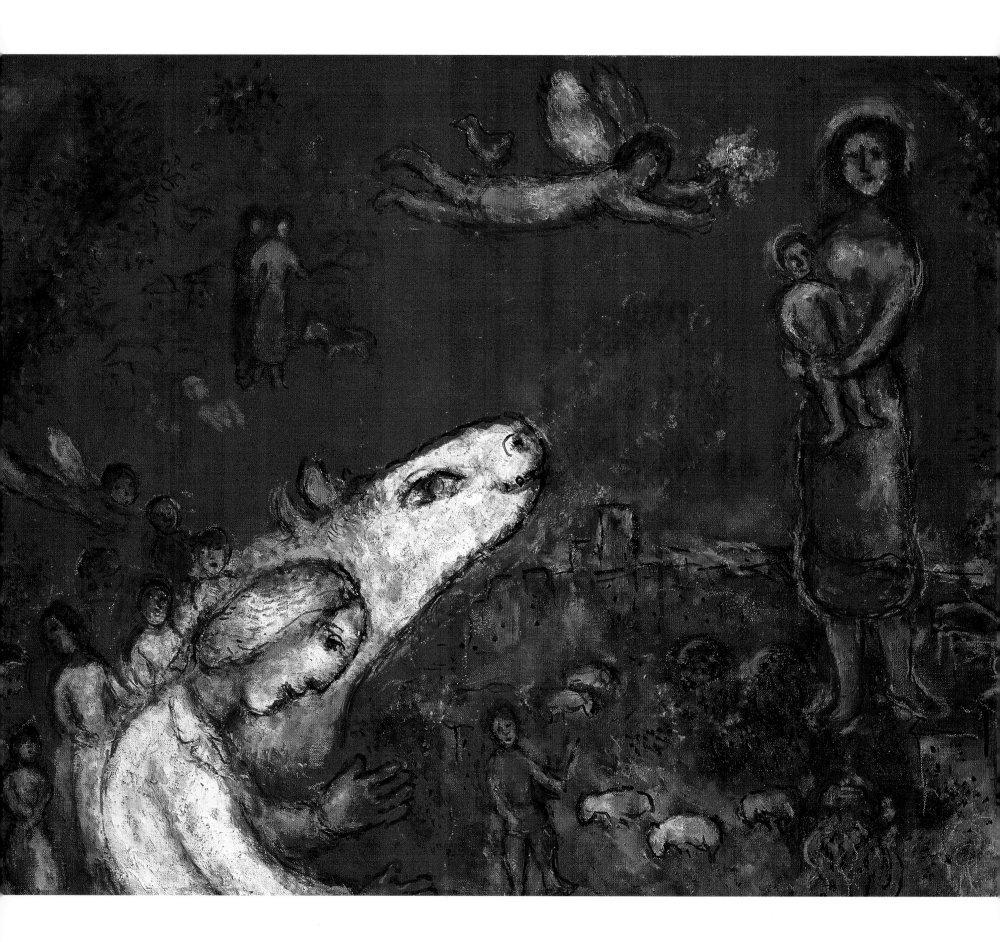

MOST OF ALL THE OTHER BEAUTIFUL THINGS IN LIFE COME BY TWOS AND THREES, BY DOZENS AND HUNDREDS.

PLENTY OF ROSES, STARS, SUNSETS, RAINBOWS . . . BUT ONLY ONE MOTHER IN THE WHOLE WORLD.

Kate Douglas Wiggins (1856–1923)
American writer, poet, and educator

IN the heavens above,

The angels, whispering to one another,

Can find, among their burning terms of love,

None so devotional as that of "Mother."

Edgar Allan Poe (1809–1849)
American writer and poet

Being a mother is
the most important role in my life.

Theresa Russell
Writer

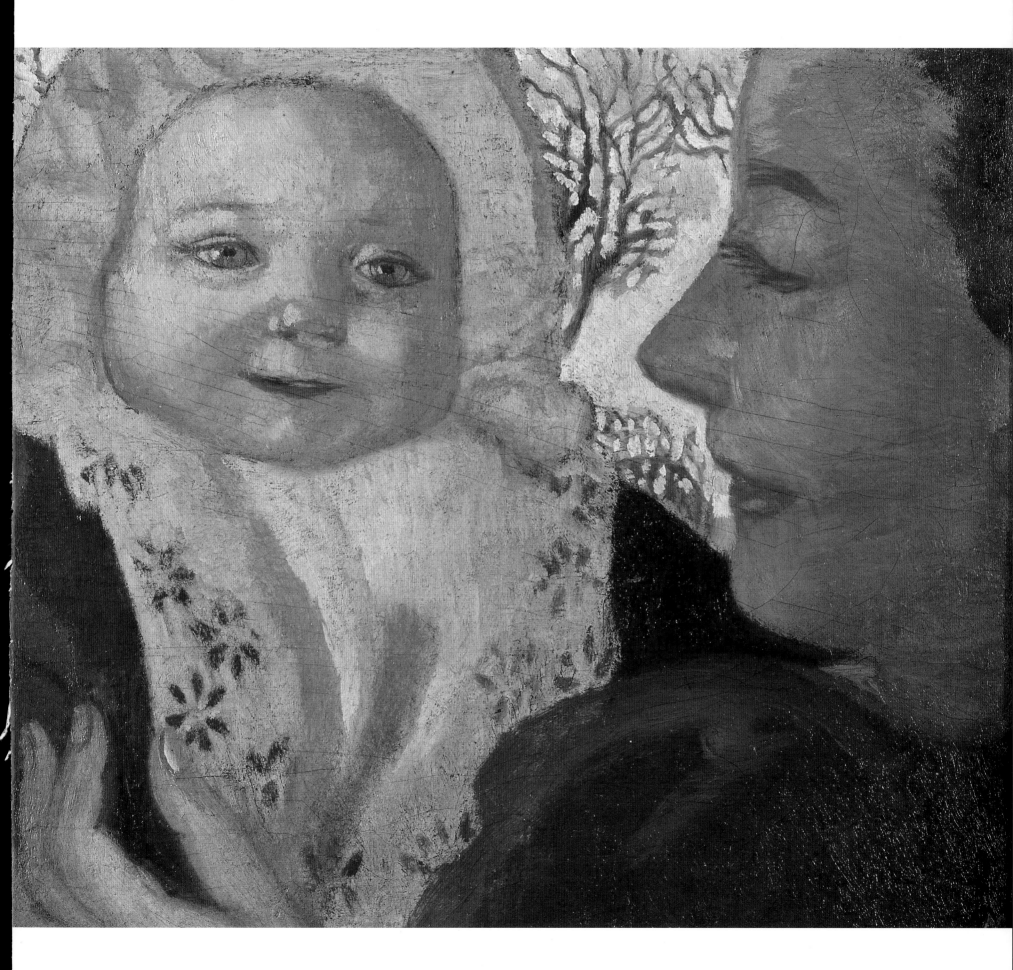

Mothers

Cover and p. 35: Detail from *The Three Ages* (1905), by Gustav Klimt. Gallery of Modern Art, Rome; E. T. Archive, London.

p. 8: *Motherhood* (1895), by Julius Gari Melchers. Musee d'Orsay, Paris; Erich Lessing/Art Resource, New York.

p. 11: *The Balloon on the Veranda* (1901), by Maurice Denis. Private Collection; Giraudon/Art Resource, New York.

p. 12: *World, Woman, and Child* (1989), by Beatricia Sagar. © Beatricia Sagar/Licensed by VAGA, New York.

p. 15: *Maternity*, by Gino Severini. © ARS, New York. Museo dell'Accademia, Etrusca, Cortona, Italy; Scala/Art Resource, New York.

p. 16: *After the Fact* (1994), by R. L. Washington. Collection of the artist; Courtesy of the Sande Webster Gallery, Philadelphia.

p. 19: *Waiting Woman* (1993), by Paul King. Courtesy of the artist.

p. 20: *The Nurse*, by Alfred Roll. Musee des Beaux-Arts, Lille, France; Giraudon/Art Resource, New York.

p. 22: *The Cradle* (1872), by Berthe Morisot. Musee d'Orsay, Paris; Erich Lessing/Art Resource, New York.

p. 24: *Maternity* (1942), by Edouard Pignon. Giraudon/Art Resource, New York.

p. 27: *The year 1918 in Petrograd*, by Kuzma Petrov-Vodkin. Tretyakov Gallery, Moscow; Scala/Art Resource, New York.

p. 28: *A Corner in an Apartment* (1875), by Claude Monet. Musee d'Orsay, Paris; Erich Lessing/Art Resource, New York.

p. 31: *The Morning Bath*, by Boris Kustodiev. Russian State Museum, Lenningrad; Scala/Art Resource, New York.

p. 32: *Mother and Child* (1887), by William-Adolphe Bouguereau. Private Collection; Bridgeman Art Library, London

p. 36: *Mother and Child*, by Paula Modersohn-Becker. Museum am Ostwall, Dortmund, Germany; Erich Lessing/Art Resource, New York.

p. 39: *New Born Babe* or *Mother and Child* (c. 1939), by William H. Johnson. National Museum of American Art, Washington, D. C.; Art Resource, New York.

p. 40: *Mother & Child* (1961), by Will Barnet. Terry Dintenfass, Inc. in association with Salander-O'Reilly Galleries, New York; © Will Barnet/Licensed by VAGA, New York.

p. 43: *Mother & Child* (1901), English School. Warrington Museum & Art Gallery, Lancaster, England; Bridgeman Art Library, London.

p. 44: *Mother and Child*, by Karoly Brocky. Museum of Fine Arts (Szepmuveszeti Museum), Budapest, Hungary; Erich Lessing/Art Resource, New York.

p. 47: *Motherhood* (1898), by Louis Emile Adan. Waterhouse and Dodd, London; Bridgeman Art Library, London/Art Resource, New York.

p. 48: *Sandia Mama* (1988/96), by Helen Mirkil. Courtesy of the artist.

p. 51: *She looks and looks, and still with new delight*, by James John Hill. Bonhams, London; Bridgeman Art Library, London.

p. 52: *Mothers—Vote Labour* (c. 1919). E. T. Archive, London.

p. 55: *Dutch Interior*, by Bernard Pothast. Towneley Hall Art Gallery & Museum, Burnley, England; Bridgeman Art Library, London.

p. 56: *The Lost Glove*, by Frederick Smallfield. Atkinson Art Gallery, Southport, Lancaster, England; Bridgeman Art Library, London.

p. 59: *The Mother*, by Silvestro Lega. Private Collection; E. T. Archive, London.

p. 60: *The Artist's Wife and her Two Daughters*, by H. Marriott Paget. Christopher Wood Gallery, London; Bridgeman Art Library, London.

p. 62: *Woman with Child in Red Suit* (c. 1916), by Charles Demuth. National Museum of American Art, Washington, D. C.; Art Resource, New York.

p. 65: *Lullaby* (1950), by Ben Shahn. © Estate of Ben Shahn/Licensed by VAGA, New York.

p. 66: *The Washerwoman* (c. 1863), by Honoré Daumier. Musee d'Orsay, Paris; Erich Lessing/Art Resource, New York.

p. 69: *Convalescent*, by Charles West Cope the Younger. Mallet and Sons Antiques, Ltd., London; Bridgeman Art Library, London.

p. 71: *Par and Her Children* (1992), by Mahvash. Courtesy of the artist.

p. 72: *The painter's first wife with their second daughter* (1899), by Maurice Denis. Musee d'Orsay, Paris; Erich Lessing/Art Resource, New York.

p. 75: *Scène paysanne* (1975), by Marc Chagall. © ARS, New York. Chagall Collection, France; Scala/Art Resource, New York.

p. 76: *On the Terrace* (c. 1890-1900), by John Henry Twachtman. National Museum of American Art, Washington, D. C.; Art Resource, New York.

p. 78: *Mother and Child*, by Mary Cassatt. Private Collection, Paris; Giraudon/Art Resource, New York.

p. 81: *Roses and Lilies*, by Mary Louise Fairchild MacMonnies. Musee des Beaux-Arts, Rouen, France. Giraudon/Art Resource, New York.

p. 82: *Jubilee Hat*, by Frank Wright Bourdillon. Private Collection; Bridgeman Art Library, London.

p. 85: *The Gathering* (1996), by Andrew Turner. Collection of Louise and Milton Mitoulis; Courtesy of the Sande Webster Gallery, Philadelphia.

p. 86: *An Interlude* (1907), by William Sargent Kendall. National Museum of American Art, Washington, D. C.; Art Resource, New York.

p. 89: *A Suburban Railroad Station* (c. 1895), by Georges d' Espagnat. Musee d'Orsay, Paris; Erich Lessing/Art Resource, New York.

p. 90: *Summer or the Dance* (1912), by Pierre Bonnard. © ARS, New York. Pushkin Museum of Fine Art, Moscow; Scala/Art Resource, New York.

p. 93: *Berthe Morisot and Her Daughter*, by Auguste Renoir. Musee du Petit Palais, Paris; Giraudon/Art Resource, New York.

p. 94: *Springtime*, by James George Bingley. Mallet and Son Antiques, Ltd., London; Bridgeman Art Library, London.

p. 97: *War* (1943), by Marc Chagall. © ARS, New York. Musee National d'Art Moderne, Paris; Scala/Art Resource, New York.

p. 98: *Grandmother, Grandson* (1994), by Marta Sanchez. Courtesy of the artist.

p. 101: *On the Dunes* (c. 1900–1910), by Sir James Jebusa Shannon. National Museum of American Art, Washington, D. C.; Art Resource, New York.

p. 102: *The Grove*, by Julius Gari Melchers. Musee d'Orsay, Paris; Giraudon/Art Resource, New York.

p. 104: *Beatrice Hastings*, by Amedeo Modigliani. Mazzotta Collection, Milan; Scala/Art Resource, New York.

p. 107: *My Mother and Me* (1994), by Mahvash. Courtesy of the artist.

p. 108: *Gabrielle and Jean*, by Auguste Renoir. Musee de l'Orangerie, Paris; Giraudon/Art Resource, New York.

p. 111: *Mother and Child* (1955), by Ben Shahn. The Nelson-Atkins Museum of Art, Kansas City, Missouri. Gift of Mr. and Mrs. George H. Bunting, Jr.; © Estate of Ben Shahn/Licensed by VAGA, New York.

p. 112: *Sistine Madonna*, by Raphael Sanzio. Staatliche Kunstsammlungen, Dresden, Germany; Erich Lessing/Art Resource, New York.

p. 115: *Gypsy Woman with a Baby* (1919), by Amedeo Modigliani. National Gallery of Art, Washington, D. C.; Bridgeman Art Library, London.

p. 116: *The Isle of Shoals Garden* or *The Garden in its Glory* (1892), by Childe Hassam. National Museum of American Art, Washington, D. C.; Art Resource, New York.

p. 119: *Reflections of Maternal Love* (1866), by Robert Julius Beyschlag. Josef Mensing Gallery, Hamm-Rhynern, Germany; Bridgeman Art Library, London.

p. 120: *The Butterfly Hunt* (1874), by Berthe Morisot. Musee d'Orsay, Paris; Erich Lessing/Art Resource, New York.

p. 123: *Valencian Fisherwomen* (1915), by Joaquin y Bastida Sorolla. Museo Sorolla, Madrid; Bridgeman Art Library, London.

p. 124: *Maternity* (1975), by Marc Chagall. © ARS, New York. Chagall Collection, France; Scala/Art Resource, New York.

p. 127: *Bernadette and Her Mother*, by Maurice Denis. Private Collection; Giraudon/Art Resource, New York.